T0333449

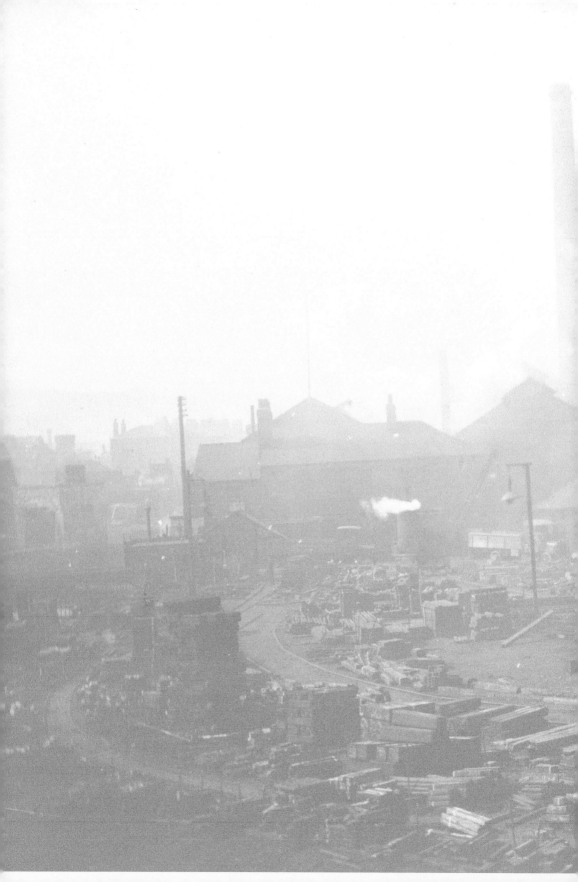

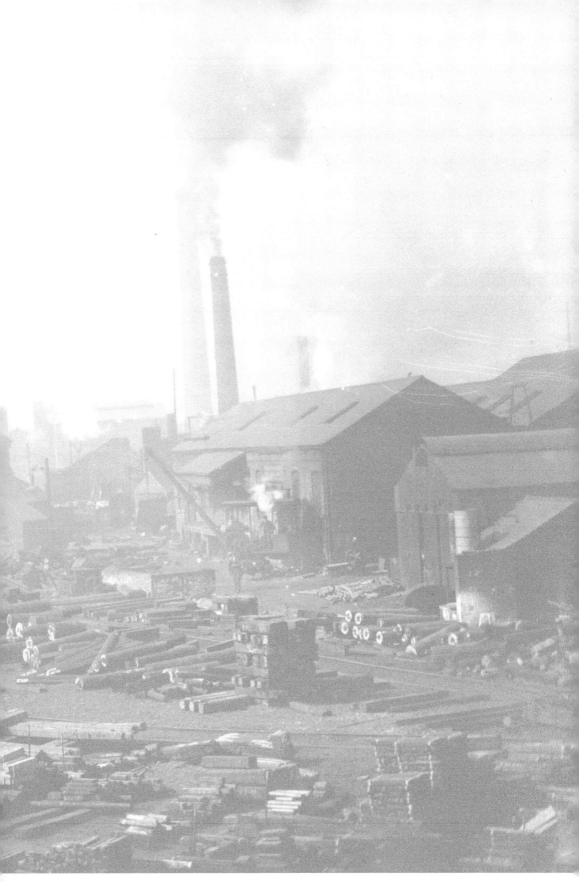

A Photographic History of

Sheffield Steel

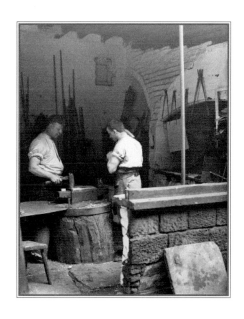

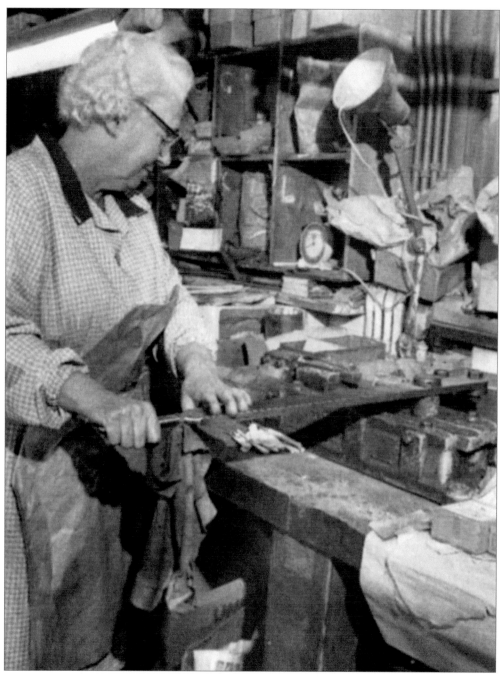

Joseph Elliot & Sons, cutlers, 1981. Mrs Gill is operating the pulling-on machine.
(*Courtesy of Sheffield Central Library*)

A PHOTOGRAPHIC HISTORY OF SHEFFIELD STEEL

GEOFFREY HOWSE

First published in the United Kingdom in 2001 by Sutton Publishing Ltd
This new paperback edition first published in 2011 by The History Press

The History Press
The Mill, Brimscombe Port,
Stroud, Gloucestershire, GL5 2QG
www.thehistorypress.co.uk

British Library Cataloguing in Publication Data
A catalogue record for this book is available from the British Library.

ISBN 0-7524-5985-1

Front endpaper: The stockyard and offices at Daniel Doncaster & Sons' Slack Works, Penistone Road, *c.* 1925. (*Courtesy of Kelham Island Museum*)
Back endpaper: Forging at Brown Bayleys, 1950s. (*Courtesy of Kelham Island Museum*)
Half title page: Double hand forging at Thomas Turner & Co.'s Suffolk Works, 1902. (*Courtesy of Kelham Island Museum*)
Title page: Aetna (or Etna) Works, Savile Street, *c.* 1852. This factory was built for Spear & Jackson in 1852. Rapid expansion of the steel industry meant that within a short time the works were sandwiched between the extension to Cammell's Cyclops Works and Thomas Firth's Norfolk Works. (*Courtesy of Kelham Island Museum*)

Typeset in 11/14pt Photina.
Printed and bound in Great Britain by Marston Book Services Ltd, Didcot.
Manufacturing managed by Jellyfish Print Solutions Ltd.

Contents

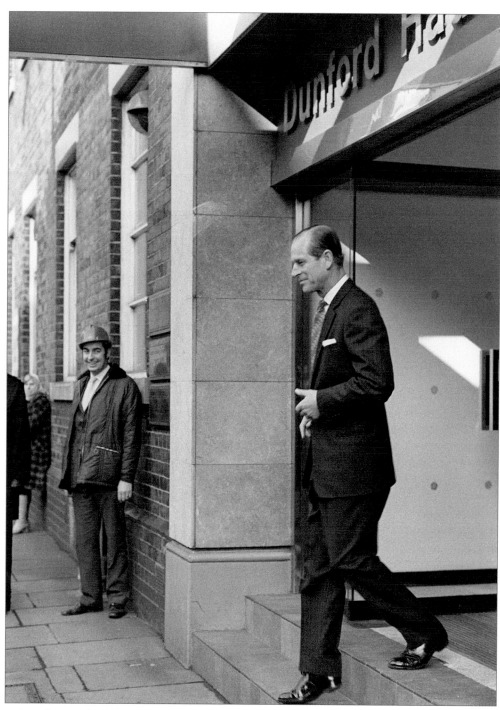

A royal visit to Sheffield's steelworks, 1970s. HRH Prince Philip, Duke of Edinburgh, is seen here at Dunford Hadfields. On the left, wearing a safety helmet, is Mr Harold Short, safety and security manager at Dunford Hadfields. (*Courtesy of Harold Short*)

Introduction

This work is by no means a textbook, nor is it a technical manual. It is simply meant to give an insight into the steel and cutlery industries for which Sheffield has become justly famous. It has not been possible to include photographs of every famous steel and cutlery company that has existed in Sheffield during the last 150 years or so, nor indeed of the numerous less well-known companies. In many cases visual images are simply not available. The owners of many steelworks were reluctant to allow photography at their works for fear of betraying industrial secrets. Many of those that did allow photography did not keep the photographs or even pass them on when their works closed. In contrast, owners of steelworks such as Jessops and Browns employed full-time photographers to record the activities and production at their works. The Firth Brown collection of over ten thousand photographs was saved and has been preserved at Kelham Island Museum. Fortunately, Sheffield's industrial museums have an extensive archive of photographs and engravings which cover many steel and cutlery works – but by no means all. A fraction of the collection at Kelham Island Museum forms the basis of this book.

I have made use of photographs which show the steelworks of Sheffield as they were until the advent of modern methods of steel production resulted in the closure of many of the city's giant industrial premises. I have attempted to capture the essence of the steel industry from a visual point of view in the greatest steel-making city the world has ever known. The greater part of the twentieth century saw Sheffield's steel and cutlery industries booming but in more recent years changes in technology and methods of production have meant that these industries, which were for centuries the biggest employers in the city, have had to adapt to cater for modern trends in a highly competitive market. In 1970, 45,000 people were working in the steel and cutlery industries in Sheffield. By the mid-1980s the number had fallen to 12,000 and in 2001 there are fewer than 8,000 steel and cutlery workers. Modern production methods mean that some jobs which once required as many as ten men can now be done by one man. Despite the enormous decline in numbers of workers, more steel is produced in Sheffield today than at any time during its history.

Sheffield, England's greenest city and one of the cleanest industrial cities in the world, in the last quarter of the twentieth century grew from being England's fifth largest city, to its fourth. Its geographic location near rich beds of iron ore and an abundant supply of timber and plentiful quantities of water determined its early development as a centre of industry. Sheffield's rivers – the Don, Sheaf, Rivelin, Loxley and Porter – have all played their part in the development of the city's industries. Documentary evidence for industry in Sheffield does not exist before the thirteenth century although it seems likely that Sheffield had already begun to exploit its industrial potential before then. The Romans are known to have burnt coal at Templeborough but exactly when the metallic resources in the area were

first exploited may never be known. Geoffrey Chaucer (*c.* 1340–1400) saw fit to mention Sheffield in his celebrated *Canterbury Tales* so it seems likely that Sheffield was already well established and indeed noted as a centre for cutlery production by that time. In 'The Reeve's Tale' Chaucer wrote: 'A Sheffield thwitel [whittler] baar he in his hose'.

Sheffield developed around the junction of the Rivers Don and Sheaf; indeed one old name for Sheffield was Escafield ('the field by the Sheaf'). Water power became the driving force in the development of industry in Sheffield. Hundreds of waterwheels were constructed to provide a source of power to drive furnace bellows and to operate machinery such as giant tilt-hammers. In the early years most metalworking was carried out on a part-time basis, probably by farmers living in the surrounding countryside. It seems likely that they would have had forges at their homes and may have rented time on the numerous water-powered tilt-hammers and other machinery in Sheffield's five river valleys. Like Rome, Sheffield was built on seven hills, which made transportation of goods difficult. The result was that particular areas specialised in certain types of goods, which were easier to carry by horse or on foot. The villages to the south of Sheffield around Abbeydale, Norton and into northern Derbyshire, built a reputation for making scythes and sickles. To the north of Sheffield, villages such as Ecclesfield and Grenoside made nails and files, while Loxley, to the west of the city, was noted for making sheep-shears. Knife cutlers tended to work in the centre of Sheffield, mostly along the banks of the River Don. In 1624 the Cutlers' Company was

Mid-Victorian view of Park Iron Works, operated by Davy Bros (founded 1830), who moved there in about 1850. The works were previously operated by Booth & Co. Davy's made rolling mills, steam hammers, Bessemer converters and other heavy plant machinery associated with steelmaking and the textile industry. (*Courtesy of Kelham Island Museum*)

incorporated by Act of Parliament as a guild of craftsmen and independent 'Little Mesters' to make rules concerning the quality of goods produced, trade marks, who could make and trade in metal goods, and how apprentices should be trained. The Cutlers' Hall in Church Street is the third such hall on the site. The present building was constructed to the designs of Samuel Worth and Benjamin Broomhead Taylor in 1832 and extended in 1881. The Cutlers' Company lost many of its statutory functions in 1814, although it still retains the right to grant trade marks to local companies. Today, the Cutlers' Company extends its membership to people involved in steelmaking, tool-making and engineering, and it remains an important influence in the city. Its main functions are the promotion and representation of Sheffield's industry. The use of the 'Made in Sheffield' mark is still controlled by the Cutlers' Company.

Originally, the raw material available from the surrounding area was sufficient for the needs of Sheffield's metal industries and the importation of iron ore from further afield did not occur until later in the history of steelmaking. Nobody has yet seen pure iron. The purest so far obtained is about 99.995 per cent pure, and is such a soft metal that for any practical purpose it is quite useless. Steel is an alloy of iron and less than 2 per cent carbon. A mixture of two or more metals is known as an alloy. There are many metal alloys but steel has more practical uses than most. Various steels have been produced (the development of special steels has become synonymous with steel production in Sheffield), containing diverse metals and elements in varying quantities. Carbon, silicon and phosphorous, which are not themselves metals, behave in alloys as though they were. Other metals such as chromium, tungsten and manganese have all been used in steel-making. Unlike wrought iron, steel holds a cutting edge, and steelmaking came to Sheffield because of the cutlery industry there.

Already well established as the most important centre for the production of cutlery, from the late seventeenth century onwards Sheffield also became the most famous area in the world for the production of high-quality steels. Sheffield became Britain's leading centre for steel production after Benjamin Huntsman, a Quaker clockmaker from Doncaster, chose Sheffield to develop his invention of crucible steel, which meant that for the first time steel could be cast as an ingot. He moved to Handsworth near Sheffield where he made his discovery in 1742. Crucible steel was a high-quality steel that found a wide range of uses and instigated a rapid expansion of steelmaking in Sheffield towards the end of the eighteenth century and in the early nineteenth century, and resulted in an enormous increase in population. To put things in perspective, in 1736 the population of Sheffield was 10,121, with a further 4,410 people living in the rural parts of the extensive parish of Sheffield. At that time the entire population of England amounted to less than six million souls. London was by far the largest centre of population with half a million people living there. Perhaps surprisingly, the next largest city was Norwich, with a population of some 30,000 people. Rapidly growing Sheffield soon overtook many cities and county towns in size. The parish of Sheffield was incorporated as the borough of Sheffield in 1843 and the town was granted a City Charter in 1893. By the time of the first official census in 1801 the population of the parish of Sheffield had risen to 45,755, of whom 31,314 resided within the central township. Just fifty years later the population numbered 135,310 inhabitants. At the beginning of the twenty-first century Sheffield has a population of over half a million.

Although the invention of crucible steel was a major development in steel production, it was still expensive to produce and could only be made in small quantities. It was not

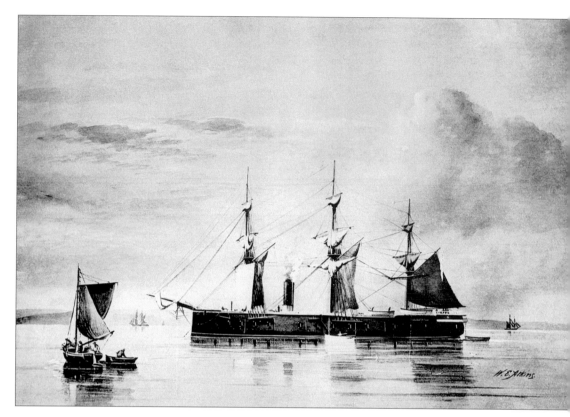

John Brown pioneered the commercial production of armour-plate in the United Kingdom in 1859–60. Cammell's were quick to follow Brown and armour-plate was soon being produced at their Cyclops Works. This 1860s engraving shows HMS *Royal Alfred*, a ship armoured by Charles Cammell & Co. Ltd. (*Courtesy of Kelham Island Museum*)

until after 1855 that the discoveries of Bessemer and Siemens enabled the production of relatively cheap steel in bulk. It was then that steel was developed suitable for heavy engineering, bridge building, ship building, armour-plating, heavy guns and other armaments. Experiments were conducted on a large scale and Sheffield became a world leader in the production of special steels. By the beginning of the twentieth century the production of high-quality steels had become the major industry. Sheffield led the way in the production of manganese steel, an extremely tough, wear-resistant steel used extensively by the railway industry, silicon steel, used for electrical components, and armour-plating. The discovery of stainless steel by Harry Brearley in 1913 at Sheffield's Brown Firth Laboratories created new opportunities in Sheffield and made possible the production of almost everything from kitchen sinks and cooking utensils to brewery equipment, aeronautical equipment and products designed for the space age.

As Sheffield's steel companies began to expand, some moved out from the town centre to the Don Valley, particularly after the building of the Sheffield & Rotherham Railway in the 1840s. Iron ore mined locally was not of a high quality and thus not suitable for

steelmaking. Better quality ores were brought in from elsewhere in the country and later ore was imported to Sheffield in large quantities from Sweden. After 1855, when bulk steel production methods were introduced, the Sheffield Ship Canal and the navigable parts of the River Don were busy with barges bringing ore to Sheffield's steelworks and transporting goods to customers many miles away. However, the railways soon became the most effective method of transportation.

Sheffield's industries manufactured metal and metal alloy products which in turn helped to advance technological discoveries. Sadly, those discoveries were sometimes directly responsible for the closure of the industrial giants from which they were spawned. I wish it were possible to include the names of *all* the steel and cutlery companies that have made Sheffield world famous, but unfortunately I have not even been able to include visual images of some of the best known. To compensate in part for those I have been unable to include, here is a short list of some of the many familiar names which were associated with Sheffield steel for so many years: Edgar Allen Engineering Ltd, Joseph Beardshaw & Son, John Bedford & Sons, Coker Bros, Eaton & Booth (Sheffield) Ltd, Hallamshire Steel & File Co. Ltd, Thos C. Hurdley (Sheffield) Ltd, Kelham Island Steelworks Ltd, Samuel Osbourne & Co. Ltd, The Sheffield Hollow Drill Steel Co. Ltd, Sheffield Rolling Mills Ltd, Jabez Shipman & Co., Shortridge & Howell, The Tinsley Rolling Mills Co. Ltd and Thomas W. Ward.

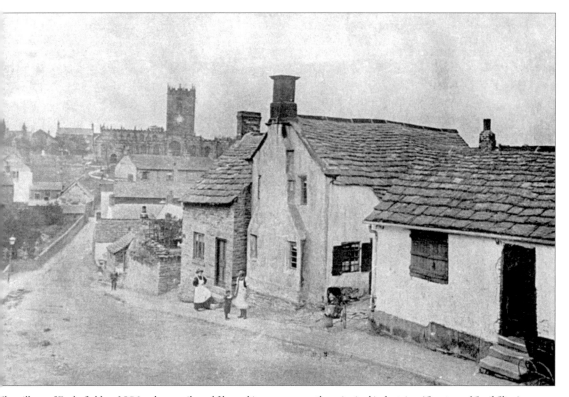

The village of Ecclesfield, *c.* 1906, where nail- and file-making were once the principal industries. (*Courtesy of Cyril Slinn*)

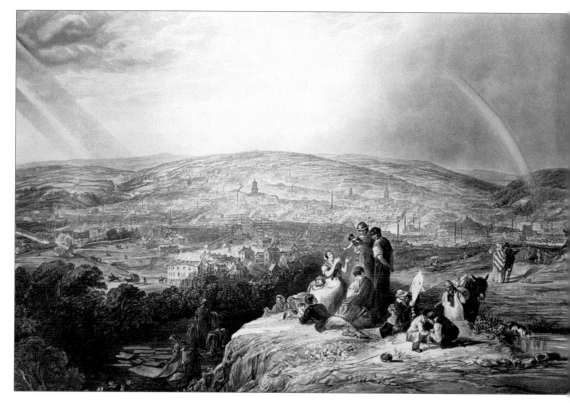

An engraving showing Sheffield from the south-east in the 1930s. (*Courtesy of John Bishop*)

I have made every effort to identify accurately subjects and individuals shown in the photographs and images contained in this book. I have attempted to give detailed descriptions in the captions based on the information available to me, but I apologise unreservedly for any errors or omissions.

Geoffrey Howse, July 2001

The Growth of Steel

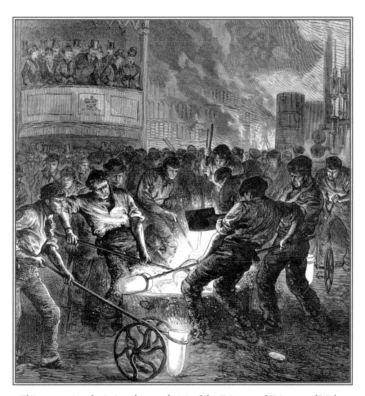

This engraving depicting the royal visit of the Prince and Princess of Wales appeared in the *Illustrated London News* on 28 August 1875. From their specially constructed box the royal couple watched a demonstration of the production of crucible steel at Messrs Firth & Sons' Norfolk Works. Here, the steelworkers teem molten steel into ingot moulds.
(*Courtesy of Kelham Island Museum*)

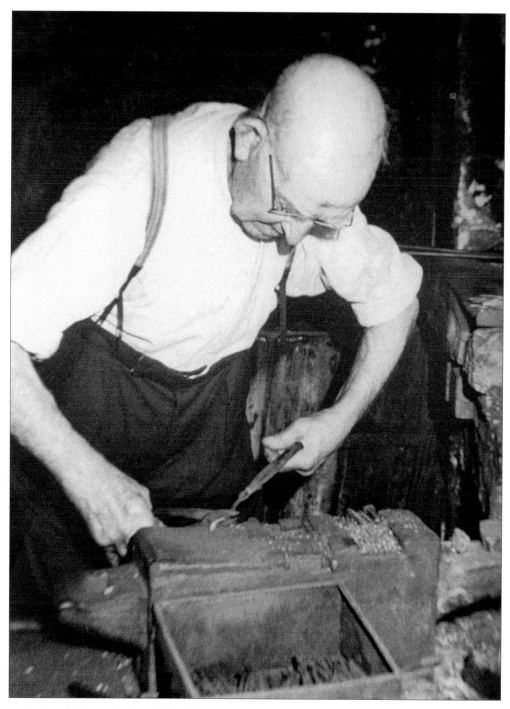

Gimlet making in Ecclesfield. Mr John Thomas Ridge retired in 1969 at the age of ninety. The closure of his smithy on his retirement severed a link with the metalworking industries of the village which had lasted for over 800 years. (*Courtesy of Cyril Slinn*)

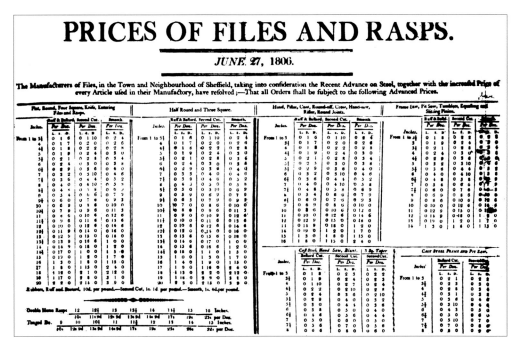

A price list for files and rasps, 27 June 1806. This list was agreed upon by the File Manufacturers' Association and the File Grinding Society, and ensured the uniformity of pricing. (*Courtesy of Kelham Island Museum*)

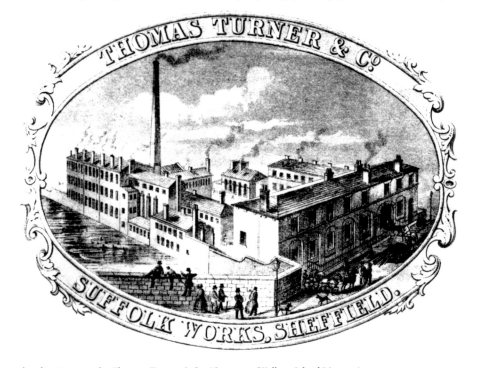

An early advertisement for Thomas Turner & Co. (*Courtesy of Kelham Island Museum*)

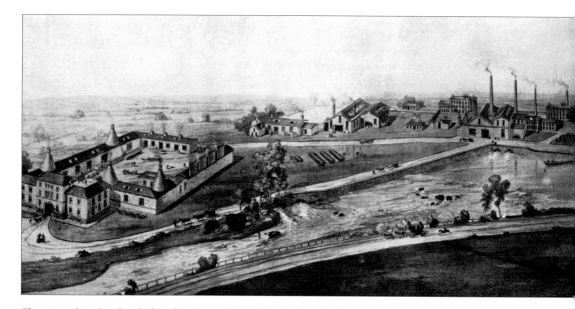

The original steelworks of Edward Vickers (1804–97) at Millsands, where two previous generations of the Vickers famil had been corn millers on the same site. This engraving shows Vickers Ltd in 1830. By 1863, owing to the rapid expansion business, Vickers had outgrown its central Sheffield site and was preparing to move to new works at Brightside. Here, in 186. Vickers had begun to build the world's largest crucible steelworks, the River Don Works, which opened in 1864. (*Courtesy Kelham Island Museum*)

Engraving of John Henry Andrew & Co.'s Toledo Steel Works, 1870s. This factory was situated on the River Don to the north west of Sheffield. (*Courtesy of Kelham Island Museum*)

Engraving of Messrs Cammell & Co.'s Steel and Spring Works at Grimesthorpe, 1870s. (*Courtesy of Kelham Island Museum*)

The armour-plate mill at Messrs Cammell & Co., 1850. Charles Cammell (1810–79) erected his Cyclops Works in Savile Street in 1846. In common with many other owners of large steelworks he named his works after a giant from mythology; others chose to name theirs after volcanoes. (*Courtesy of Kelham Island Museum*)

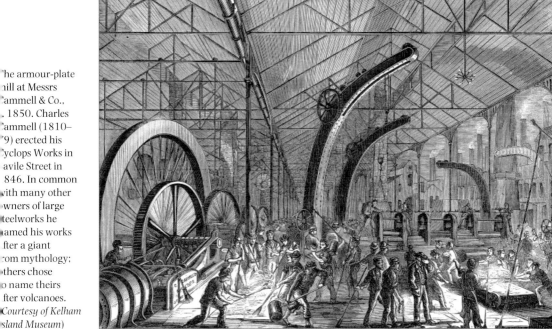

21

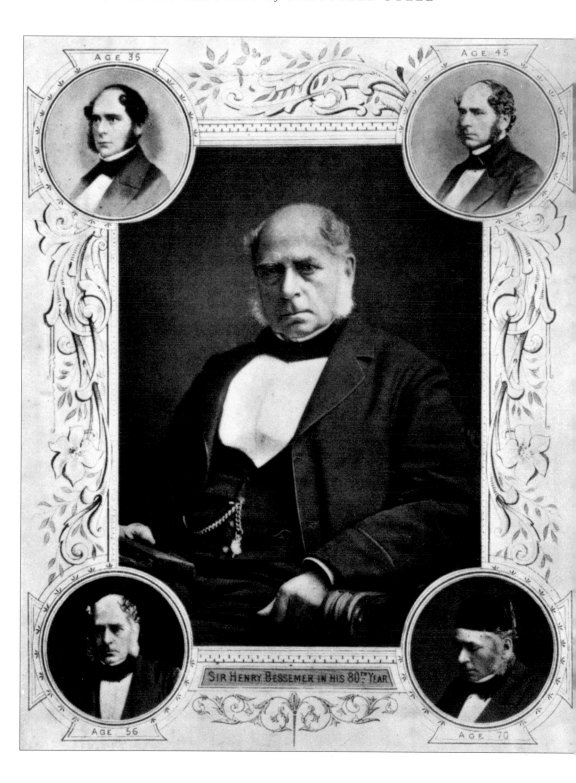

AGE 35

AGE 45

AGE 56

AGE 70

SIR HENRY BESSEMER IN HIS 80TH YEAR

(*Opposite*): Sir Henry Bessemer (1813–98), pictured here in his 80th year, in 1892. An inventor and engineer, Bessemer was born in Charlton, Hertfordshire. Largely self-taught, he learned metallurgy in his father's type furnace. In the 1850s he patented numerous inventions in response to the need for guns in the Crimean War (1853–6). In particular he took out a series of patents covering the Bessemer process, an economical method by which molten pig-iron could be turned directly into steel by blowing air through it in a tilting converter. The raw materials were placed into an egg-shaped open-ended furnace, and air was blasted into the molten pig-iron through the open end; this burnt the carbon and other elements and formed steel. The Bessemer process meant that steel could be made in much greater quantities than previously and much more cheaply – at about one-fifth of the previous price. This invention sparked the commencement of bulk steel production. Bessemer announced his invention in London in 1856 and within two years he had moved to Sheffield to open the Bessemer Steel Works in Carlisle Street. He set about persuading other steel producers to take out licences to use his process and install their own converters. Since the cheaper Bessemer steel was of a poorer quality than crucible steel and not at all suitable for cutlery, edge tools and more specialised items, the process was not at first as eagerly adopted as Bessemer had hoped. John Brown was the first to take out a licence in 1860, followed by Charles Cammell in 1861. Samuel Fox of Stocksbridge took out a licence in 1862. Bulk steel manufacture was soon a major feature of Sheffield's steel industry. Bessemer steel was suitable for heavy engineering work and the construction of bridges, railways and ships, and by the end of the nineteenth century more Bessemer steel was being produced in Sheffield (and Britain as a whole) than crucible steel. However, it was crucible steel that reigned supreme when it came to the production of quality steel products. Nevertheless the Bessemer process proved so successful that by 1880 production of Bessemer steel in the United Kingdom reached almost a million tons. At this time cast steel made in crucible pots amounted to one-tenth of the production of Bessemer steel. (*Courtesy of Kelham Island Museum*)

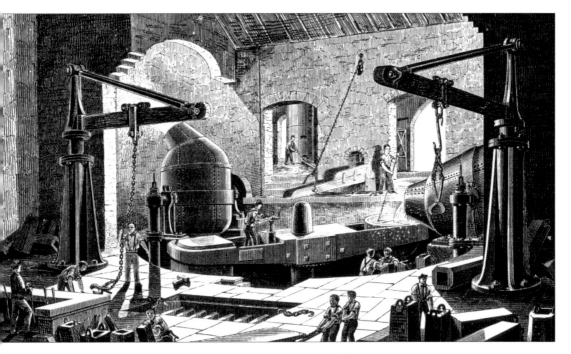

An early engraving of the Bessemer steel shop at Messrs Bessemer & Co. Ltd, showing two Bessemer converters in operation. (*Courtesy of Kelham Island Museum*)

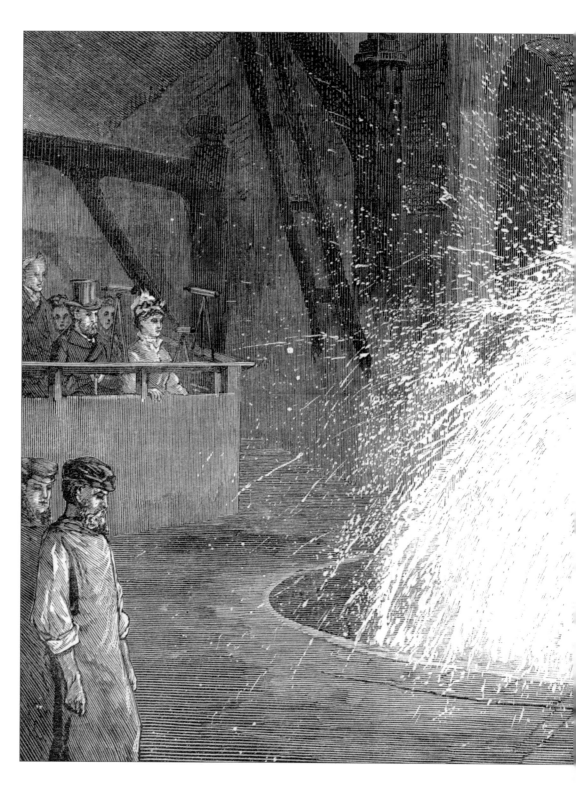

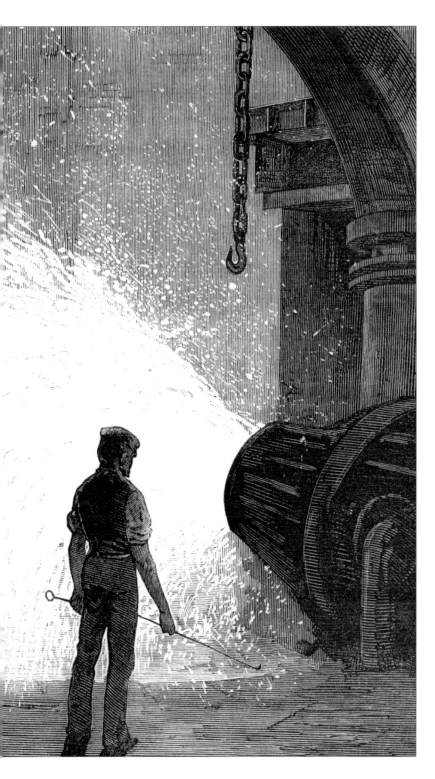

A late nineteenth-century engraving showing the Bessemer steel process at Cammell's Cyclops Works. (*Courtesy of Kelham Island Museum*)

A selection of Cammell's Cyclops Works, photographed in the late nineteenth century. The selection of castings includes steel spurwheels and other gearing. (*Courtesy of Kelham Island Museum*)

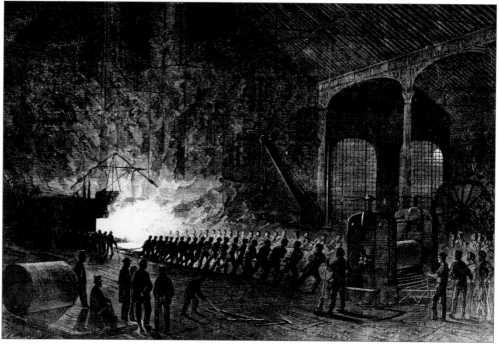

This nineteenth-century engraving shows steel being rolled for ship building at the Atlas Steelworks in Savile Street. This was the second Sheffield steelworks to bear the name Atlas, and both were owned by the same man, Sir John Brown (1816–96). John Brown began his manufacturing career in the steel business when he set up his first works in Orchard Street. He later moved to new premises, the Atlas Steel Works, and specialised in the manufacture of crucible steel files. He went from strength to strength after patenting the conical spring and buffer, designed to stop railway carriages from crashing together. By 1853 he had four works, all in different districts of Sheffield. Deciding to consolidate his interests and amalgamate all his operations at one site, in 1854 he purchased the Queens Works, which occupied a 3-acre site in Savile Street. Renamed the Atlas Works, his new premises opened in 1856. (*Courtesy of Kelham Island Museum*)

CHARLES CAMMELL & CO.,

THE CYCLOPS

STEEL WORKS,

SHEFFIELD,

(LATE JOHNSON, CAMMELL & CO.)

No. 5, BARGE YARD, BUCKLERSBURY,

LONDON;

No. 90, JOHN STREET,

NEW YORK;

Nos. 51 & 53, WATER STREET, BOSTON;

AND

COMMERCE STREET, PHILADELPHIA,

Respectfully solicit Manufacturers, Merchants, and Consumers generally, to inspect the various operations at their Works as above, and the extensive Assortment of Patterns at their LONDON, NEW YORK, BOSTON, and PHILADELPHIA HOUSES.

Advertisement for Charles Cammell & Co., 1854. (*Courtesy of Kelham Island Museum*)

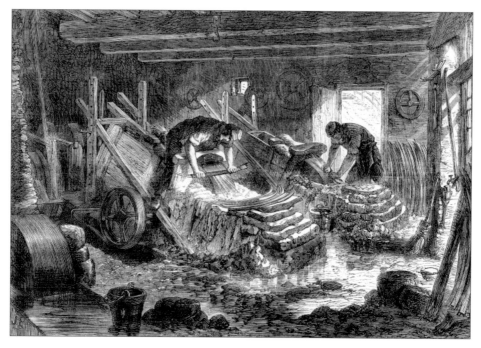

Scythe grinders (above) and saw grinders at work, from a series of mid-nineteenth-century engravings illustrating the Trades of Sheffield, which appeared in the *Illustrated London News* on 6 January 1864. (*Courtesy of Kelham Island Museum*)

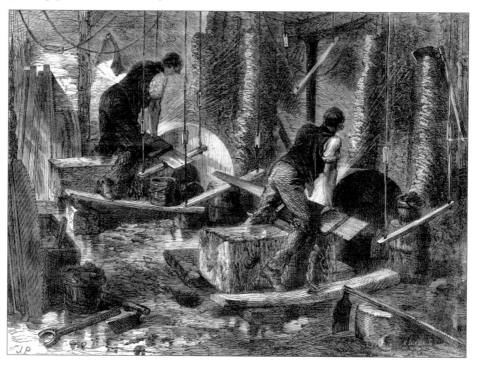

ATLAS STEEL & IRON WORKS,

SHEFFIELD.

JOHN BROWN & CO.

(LIMITED),

MANUFACTURERS OF

𝔚𝔢𝔩𝔡𝔩𝔢𝔰𝔰 𝔍𝔯𝔬𝔫 𝔞𝔫𝔡 𝔖𝔱𝔢𝔢𝔩 𝔗𝔶𝔯𝔢𝔰,

RINGS (to 14 Feet Diameter),

ATLAS STEEL RAILS, STRAIGHT & CRANK AXLES,
PISTON-RODS, BESSEMER STEEL FORGINGS
AND CASTINGS OF EVERY DESCRIPTION.

PATENT

PAPER-CENTRE RAILWAY WHEELS,

RAILWAY SPRINGS, BUFFERS, POINTS, CROSSINGS, SWITCHES,
WHEELS AND AXLES, FILES, TOOLS, SPIEGELEISEN,
FOUNDRY AND FORGE PIG IRON.

BESSEMER, CRUCIBLE AND ALL KINDS OF STEEL.

PATENTEES AND MAKERS OF

SPECIAL CHROME STEEL

FOR TOOLS, BRIDGE WORK, &c.

LONDON OFFICES, 10, John Street, Adelphi, W.C.

Advertisement for John Brown & Co. Ltd, 1879. Among other things, the factory offered 'Weldless Iron and Steel tyres' and 'Paper Centre Railway Wheels'. (*Courtesy of Kelham Island Museum*)

A late nineteenth-century view of the converting furnaces at Thomas Firth & Sons' Norfolk Works. Often known as cementation furnaces (the term being derived from the process by which carbon was introduced into the iron, known as 'cementation') these furnaces were used for converting iron bars into blister steel. At one time there were more than 250 such structures in Sheffield. Only one survives, and can be seen in Doncaster Street. It was one of five furnaces in Daniel Doncaster's works, opened in 1831. A plaque states that it was the last cementation furnace to be used in Sheffield, in the period from October 1951 to January 1952. (*Courtesy of Kelham Island Museum*)

CHARLES CAMMELL & CO.,

MANUFACTURERS OF THE PATENT

MACHINE FILES,

ON SCIENTIFIC AND PECULIAR PRINCIPLES,

PRODUCING THEIR

IMPROVED AND CELEBRATED QUALITY,

LONG KNOWN TO THE

ENGINEERING AND RAILWAY WORLD.

INVENTORS OF THE

NOW UNIVERSALLY ADOPTED

CURVILINEAR TANGED FILES,

Registered No. 685.

SOLE MANUFACTURERS OF THE

CONTINUOUS TOOTH CONCAVE AND CONVEX FILES,

FOR WHICH

The Medal of the Scottish Society of Arts & Manufactures

WAS AWARDED, REGISTERED No. 1092; ALSO

MEDALS OF THE GREAT EXHIBITION, 1851.

C. C. & Co. beg to observe, that in the Hardening and Tempering of FILES, they have adopted such decidedly superior principles as to retain and fix in the Steel the greatest possible amount of Carbon, ascertained by considerable research and numerous experiments in Chemical Science, aided by those safe and invaluable guides—long practice and great experience.

IN THE SEVERAL DEPARTMENTS OF THEIR VARIOUS MANUFACTURES

THE CYCLOPS STEEL WORKS STAND UNRIVALLED.

CHARLES CAMMELL & CO.,

MANUFACTURERS AND MERCHANTS,

IMPORTERS OF THE MOST CELEBRATED BRANDS OF

RUSSIAN, SWEDISH,

AND OTHER

FOREIGN IRONS,

PECULIARLY ADAPTED FROM THE PURITY OF THEIR ORE

FOR

STEEL PURPOSES,

WHICH ARE

CARBONIZED, CONVERTED, MELTED AND REFINED

AT THEIR FURNACES,

AT THE

CYCLOPS STEEL WORKS,

SHEFFIELD.

An 1856 advertisement for Charles Cammell & Co., manufacturers of the 'Patent Machine Files, on Scientific and Peculiar Principles'. (*Courtesy of Kelham Island Museum*)

Another advertisement for Charles Cammell & Co., 'importers of the most celebrated brands of Russian, Swedish and other Foreign Irons, peculiarly adapted from the purity of their ore for steel purposes'. (*Courtesy of Kelham Island Museum*)

Nineteenth-century advert-isement for Thomas Firth & Sons, Norfolk Works, Sheffield. (*Courtesy of Kelham Island Museum*)

THOMAS FIRTH & SONS,

NORFOLK WORKS, SHEFFIELD,

MANUFACTURERS OF EVERY DESCRIPTION OF

Cast Steel, Weldless Crucible Cast Steel Tyres,

TO ANY SIZE OR SECTION,

CAST STEEL STRAIGHT & CRANK AXLES,

MARINE, LOCOMOTIVE, AND OTHER CRANK SHAFTS,

AND EVERY DESCRIPTION OF LARGE FORGINGS FOR ENGINEERING PURPOSES, IN THE ROUGH OR FINISHED STATE, UP TO 15 TONS WEIGHT.

Every description of

CAST STEEL

For Tools, Chisels, Taps, Dies, Springs, &c.

Shear, German, and Blister Steel.

Also,

Homogeneous Steel

Made especially for Ordnance, in Forged or Finished State, up to 15 Tons Weight.

CAST STEEL SHOT, SHELL, &c.

Homogeneous Steel

For Rifle Barrels, Rolled Taper, and Rough Bored.

Cast Steel for Swords, Bayonets, and Gun Work in General.

ALSO, FILES, SAWS, AND EDGE TOOLS OF EVERY DESCRIPTION.

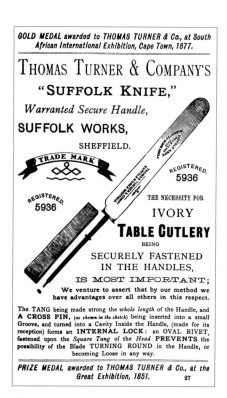

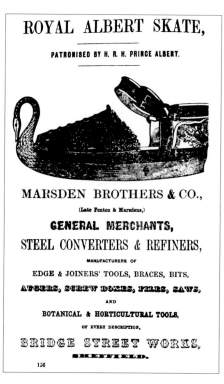

A selection of advertisements for Sheffield's steel works: Thomas Turner & Company (1879); Marsden Brothers & Co. (undated); John Brown & Co. (undated); and George Butler & Company (1879). (*All by courtesy of Kelham Island Museum*)

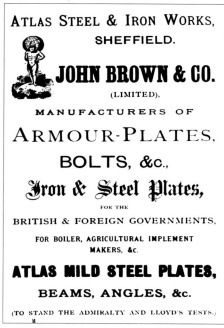

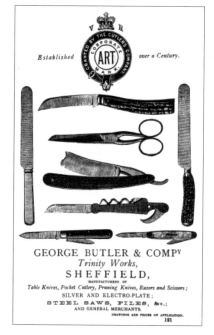

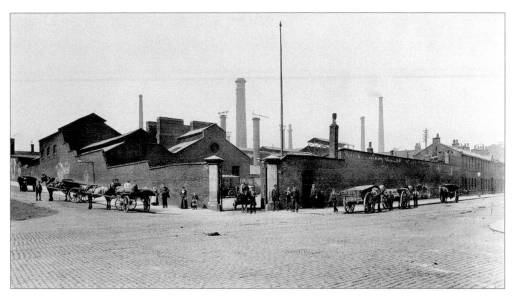

The entrance to the East Forge and the rolling mills at Cammell's Cyclops Works, 1890s. (*Courtesy of Kelham Island Museum*)

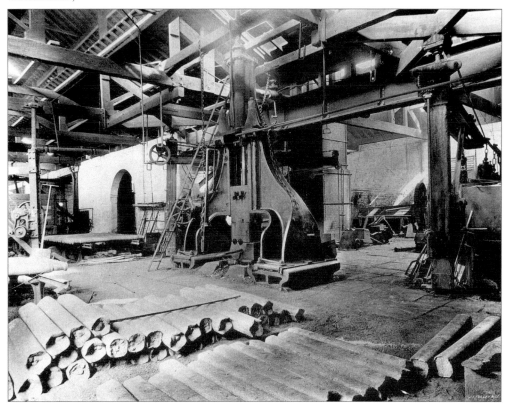

Carriage and wagon axle hammers at Cammell's Cyclops Works, 1890s. (*Courtesy of Kelham Island Museum*)

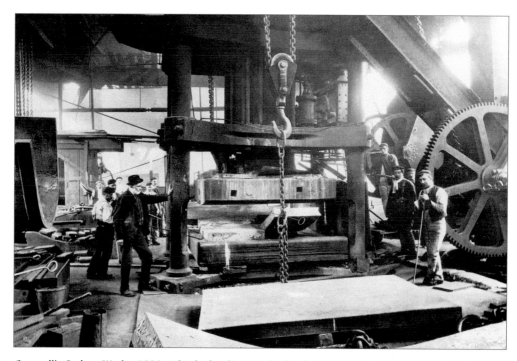

Cammell's Cyclops Works, 1890s. This hydraulic press for bending armour-plates was situated in the West Forge. After 1860, when John Brown had established his pioneering methods of producing armour-plate commercially, the demand for armour-plating rapidly increased and before the end of the decade three-quarters of the iron-clad warships in the British fleet carried armour-plating manufactured at Browns. By the late nineteenth century the rival firms of Brown's and Cammell's had a virtual monopoly in the production of armour-plate in Britain. (*Courtesy of Kelham Island Museum*)

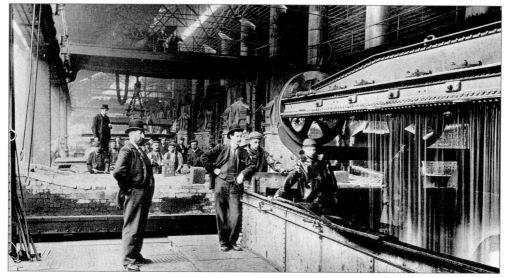

Cammell's Cyclops Works, West Forge, 1890s. The sprinkler was used for hardening steel armour-plates. (*Courtesy of Kelham Island Museum*)

The new armour-plate bending press in the
West Forge at Cammell's Cyclops Works, 1890s.
(Courtesy of Kelham Island Museum)

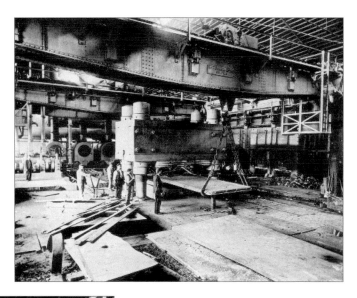

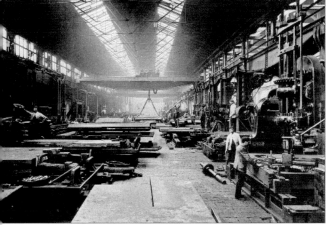

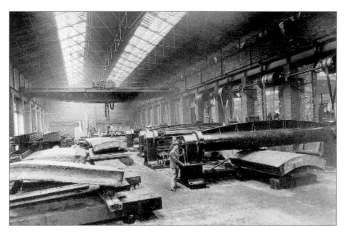

Two views of the armour-plate finishing shop,
West Forge, Cammell's Cyclops Works, 1890s.
(Both by courtesy of Kelham Island Museum)

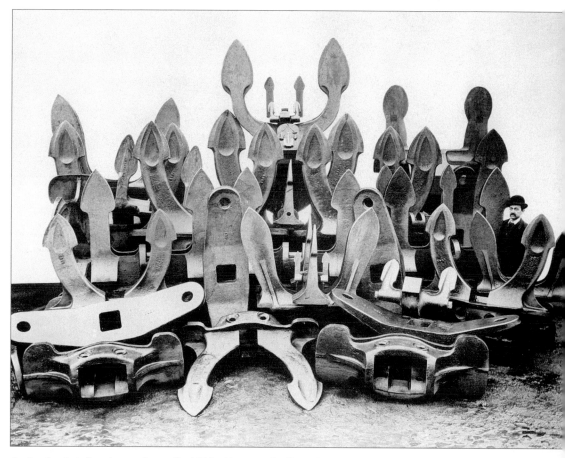

Anchor head steel castings at Cammell's, 1890s. (*Courtesy of Kelham Island Museum*)

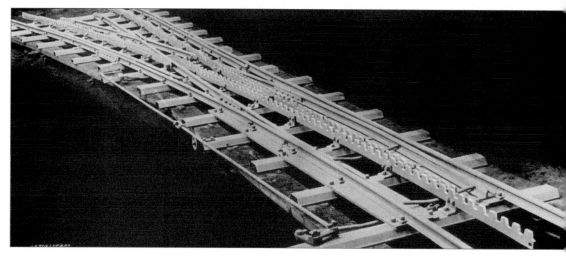

Double track rails manufactured by Cammell's for mountain railways, 1890s. (*Courtesy of Kelham Island Museum*)

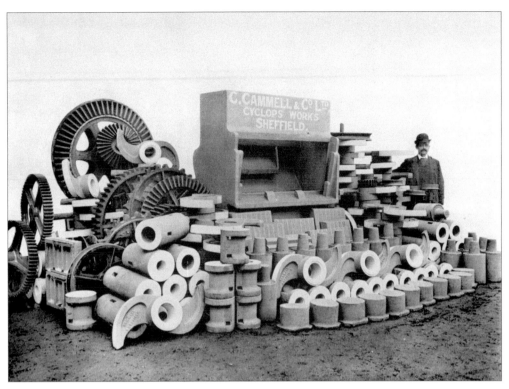

Castings of various sizes for use in mining machinery, pictured at Cammell's, 1890s. (*Courtesy of Kelham Island Museum*)

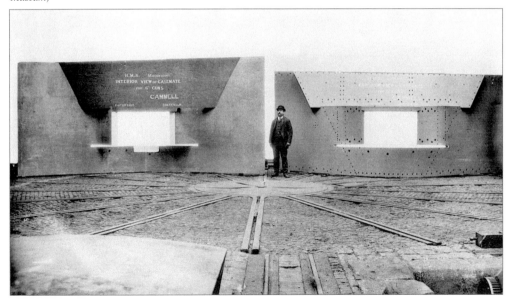

Casemates for the protection of the 6-inch guns on HMS *Magnificent*, pictured at Cammell's Grimesthorpe Steel and Ordnance Works, 1897. (*Courtesy of Kelham Island Museum*)

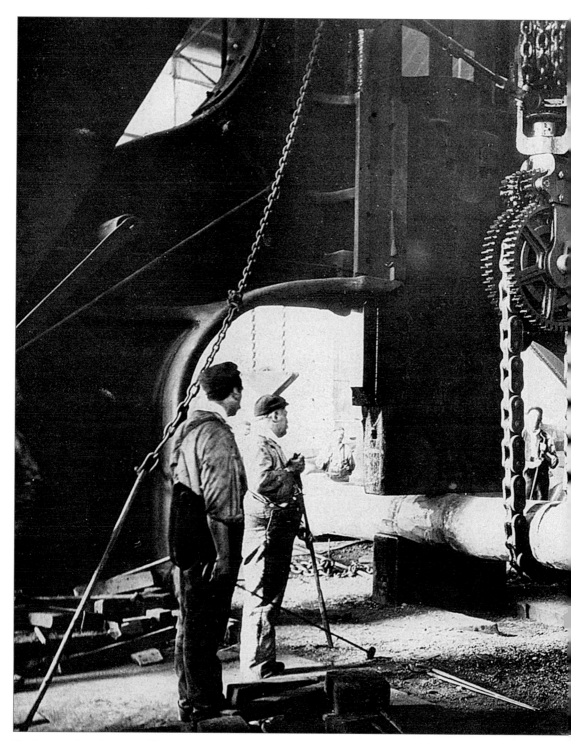

Forging a gun barrel at Cammell's Grimesthorpe Steel and Ordnance Works, 1890s. (*Courtesy of Kelham Island Museum*)

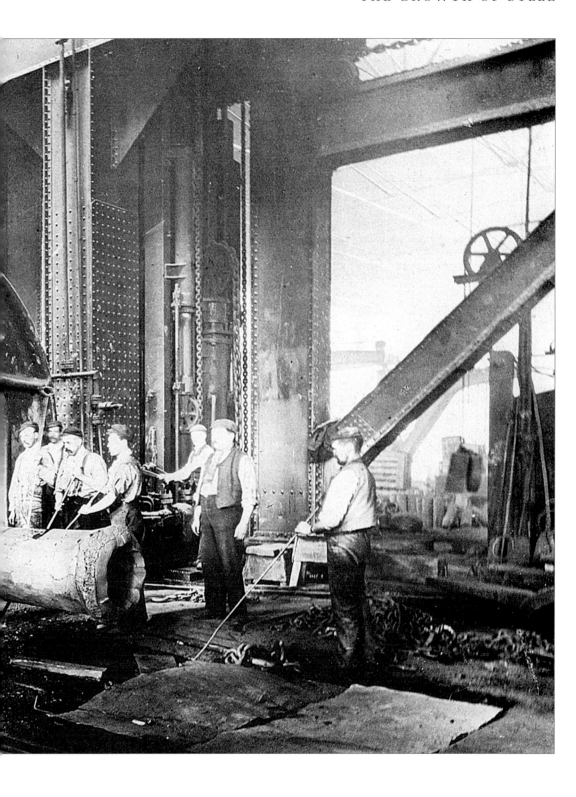

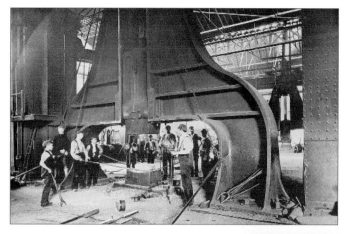

Three views taken at Cammell's Grimesthorpe Steel and Ordnance Works in the 1890s. (Top): the 7-ton tyre hammer; (middle): forging a crankshaft under a 30-ton steam hammer; (bottom): the 6,000-ton hydraulic forging press. (*All by courtesy of Kelham Island Museum*)

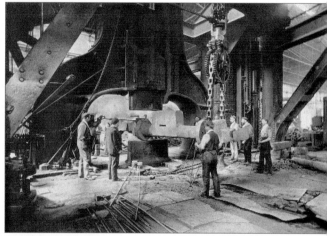

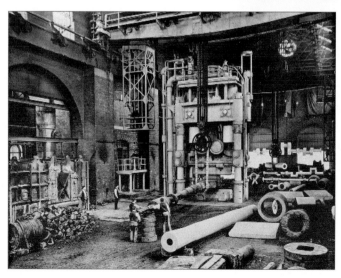

Crucible Steel

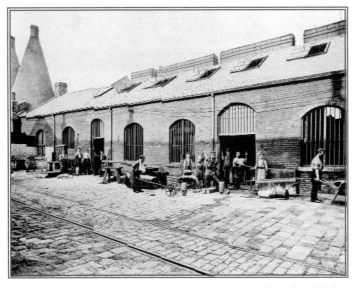

Exterior view of the crucible steel melting shop at Cammell's Cyclops Works, 1890s. (*Courtesy of Kelham Island Museum*)

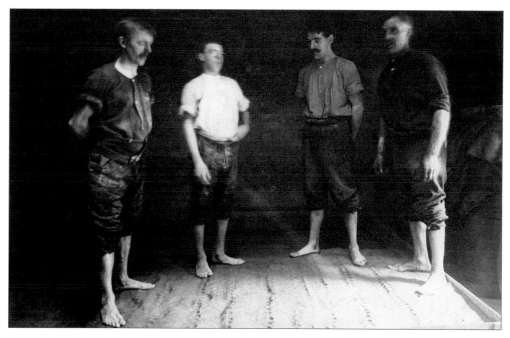

Workers at Cammell's Cyclops Works making crucible pots, 1890s. Crucible steel was invented by Benjamin Huntsman (1704–76) in 1742 at a foundry he had opened in Sheffield in about 1740, during his research to find a high-quality steel to make watch parts. The crucibles in which crucible steel is made have themselves to be manufactured. In order to make a crucible, different kinds of clay (and sometimes old crucibles) are ground down and mixed together with water in a large trough. It is then worked for several hours by men treading it with their feet. (*Courtesy of Kelham Island Museum*)

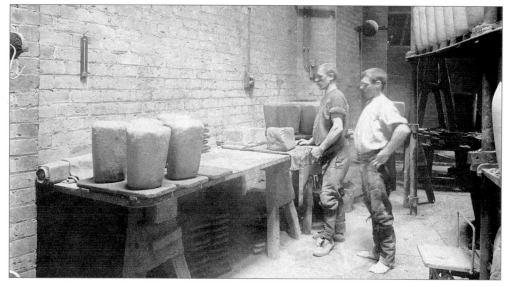

The kneaded clay is then cut into lumps of suitable size and worked by hand to release any trapped air. On the right, a lump of clay is ready to be kneaded by hand. In the left foreground are lumps of clay that have already been kneaded and shaped ready for the mould. (*Courtesy of Kelham Island Museum*)

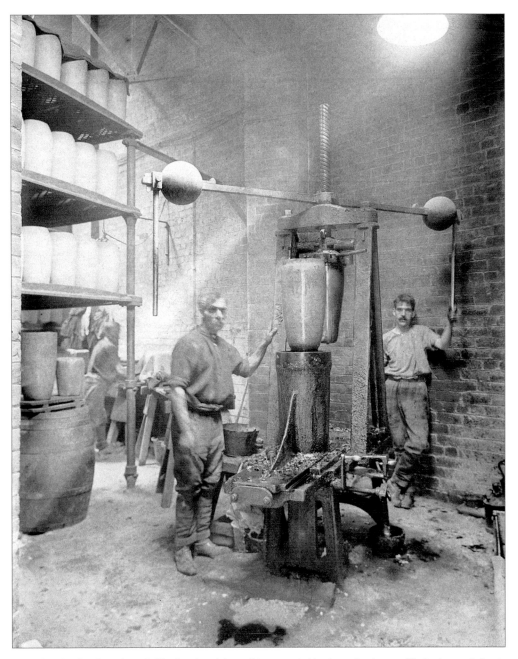

After the clay has been kneaded by hand and formed into a suitable shape for the mould, the lump of clay is put into a steel mould or flask and a plug is driven down into it by a hand-worked press. This allows the correct weight and thickness of the crucible to be achieved. After removal from the mould the crucible pot was left to dry out and harden. Once hardened these crucibles can withstand the fiercest of fires, and can be used several times, providing they are not allowed to cool. However, most crucibles were not used more than two or three times. As soon as a crucible cools it cracks and cannot be used again. Most crucibles were ground down and mixed with fresh clay to make new crucibles. (*Courtesy of Kelham Island Museum*)

Three stages in the production of a crucible steel ingot. (*Courtesy of Kelham Island Museum*)

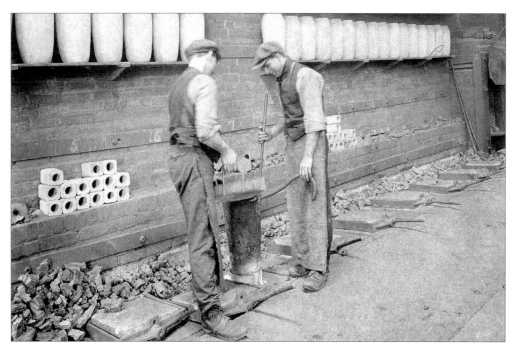

Steelworkers 'charging' a crucible pot at Cammell's Cyclops Works, 1890s. (*Courtesy of Kelham Island Museum*)

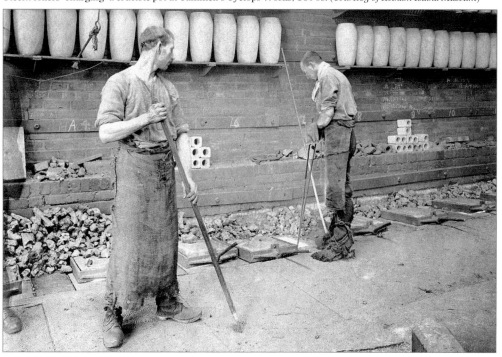

Lifting the lid to view a 'melt' during the making of crucible steel at Cammell's Cyclops Works, 1890s. (*Courtesy of Kelham Island Museum*)

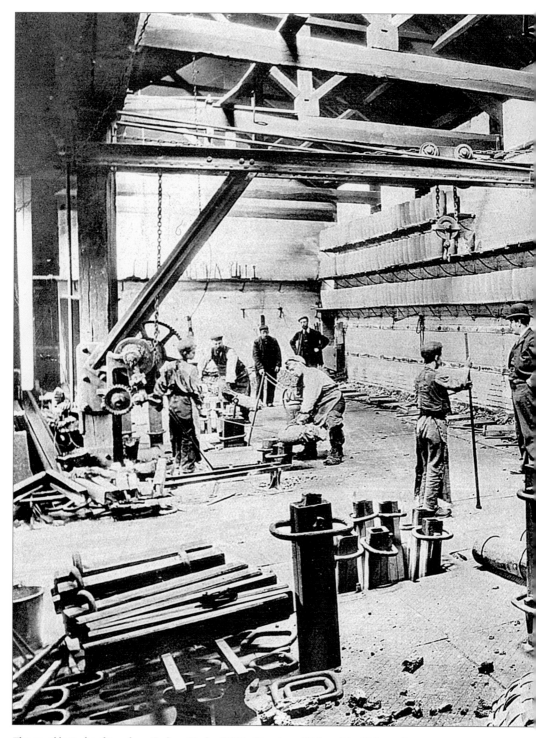

The crucible steel melting shop, Cyclops Works, 1890s. (*Courtesy of Kelham Island Museum*)

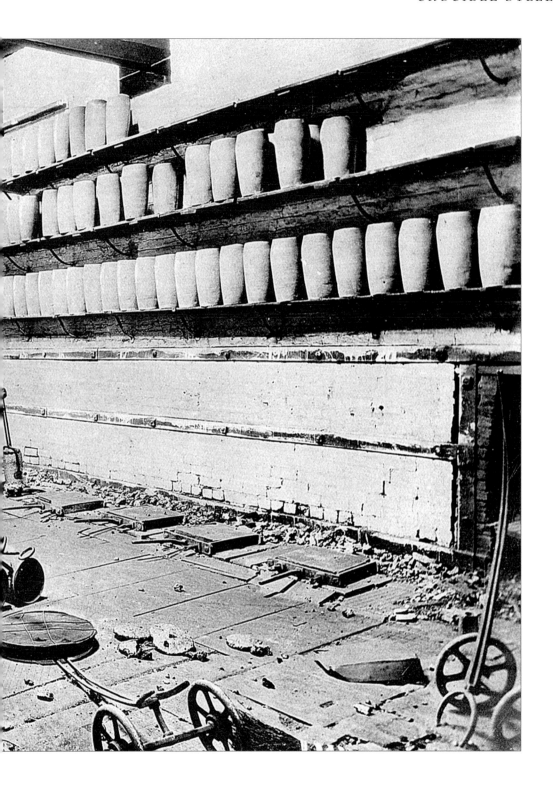

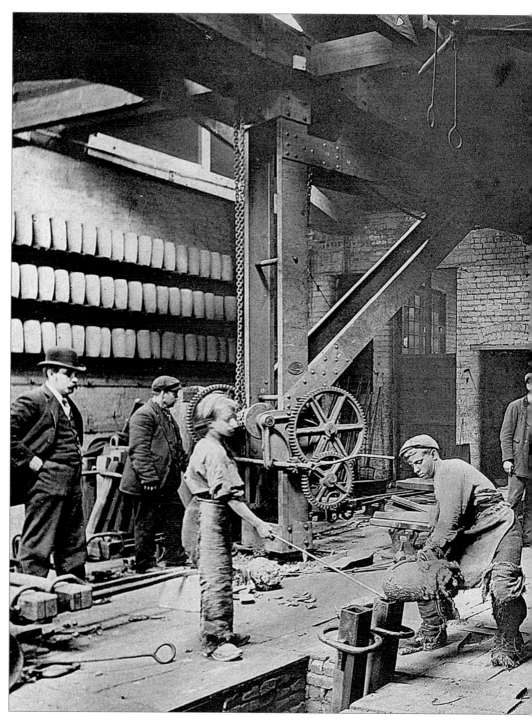

Interior of the crucible steel melting shop in the East Forge at Cammell's Cyclops Works, 1890s. (*Courtesy of Kelham Island Museum*)

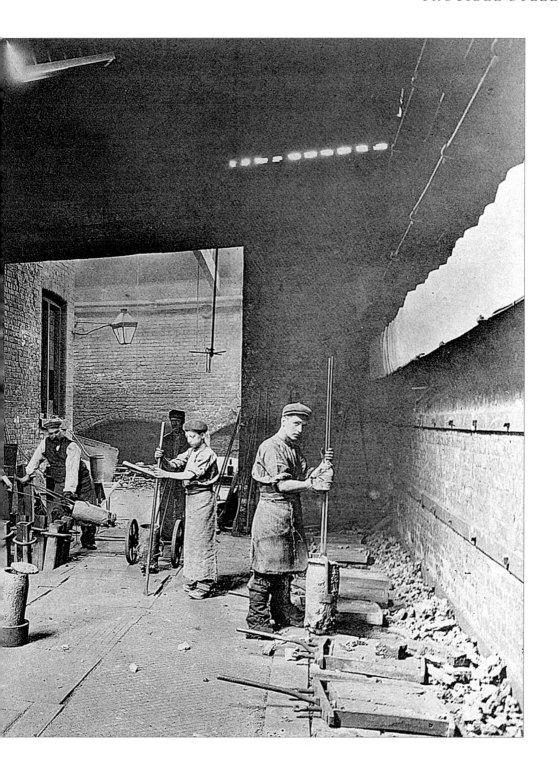

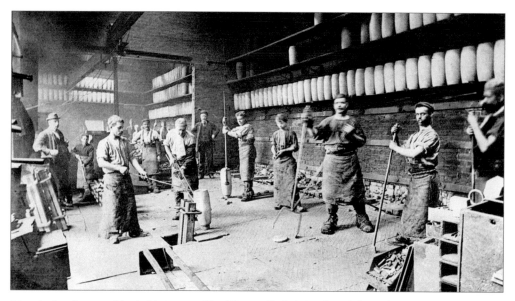

'Teeming' molten crucible steel into a mould at Thomas Firth & Sons' Norfolk Works, 1890s. Note the thick aprons and protective leg and foot attire, worn to guard against burns from molten steel. (*Courtesy of Kelham Island Museum*)

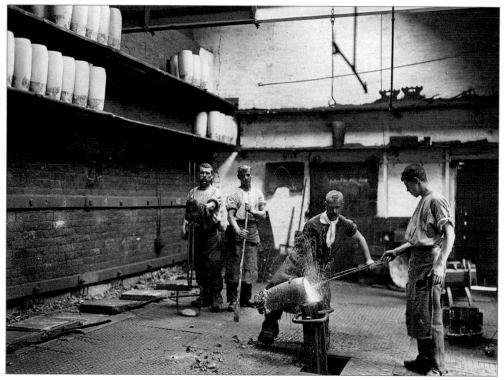

Casting a large crucible steel ingot at Thomas Turner & Co.'s Suffolk Works in 1902. (*Courtesy of Kelham Island Museum*)

The Development of
the Steel Industry

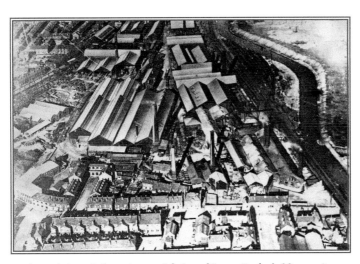

An early twentieth-century aerial view of Brown Bayley's 32-acre site.
Originally called Brown, Bayley & Dixon, the firm was founded in Attercliffe
in 1871 by George Brown, a nephew of John Brown, in order to manufacture
Bessemer steel and railway tracks. (*Courtesy of Kelham Island Museum*)

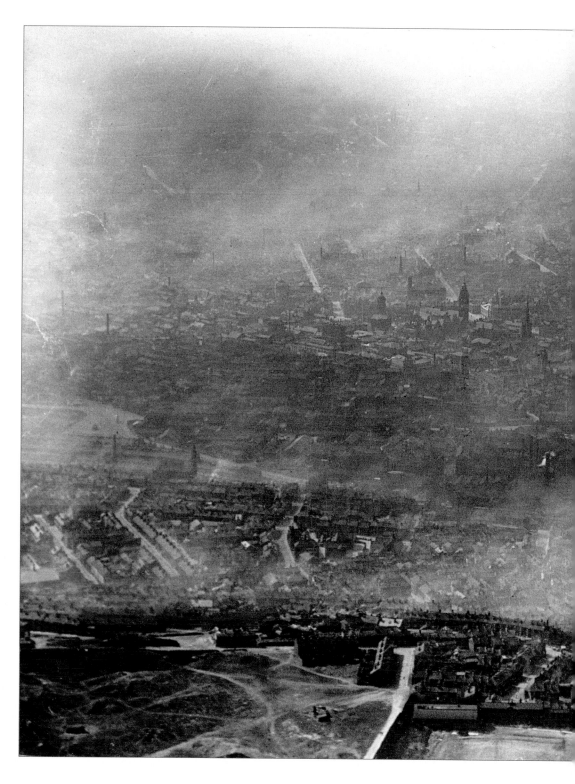

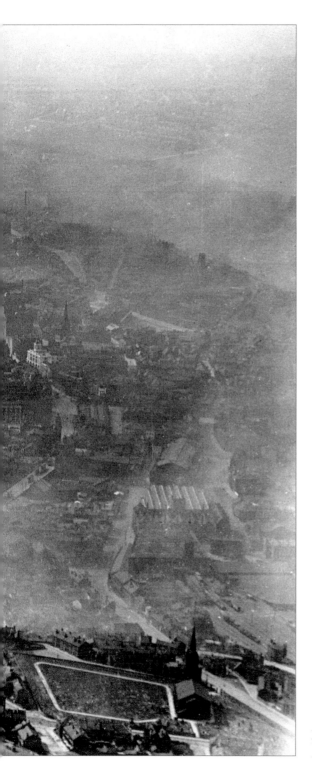

An early twentieth-century aerial view of Sheffield, taken from a balloon. (*Courtesy of Kelham Island Museum*)

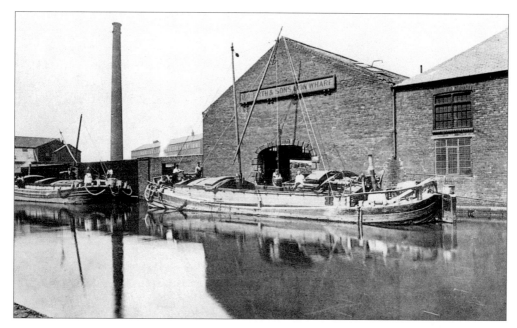

Barges delivering Swedish iron to the Iron Wharf of Thomas Firth & Sons, Effingham Road, in the early 1900s. The wharf was built in about 1860 on the banks of Sheffield Ship Canal. Firths imported wrought-iron bars from many countries; those from Sweden were used in the cementation process because of their low sulphur and phosphorous content. (*Courtesy of Kelham Island Museum*)

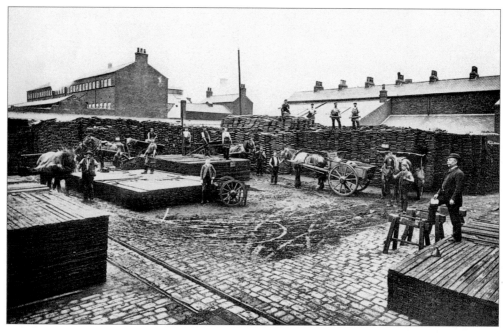

The yard at Thomas Firth & Sons' Iron Wharf, Effingham Road, early 1900s. About 6,000 tons of Swedish iron is stacked in piles ready for delivery to Firth's Norfolk Works. (*Courtesy of Kelham Island Museum*)

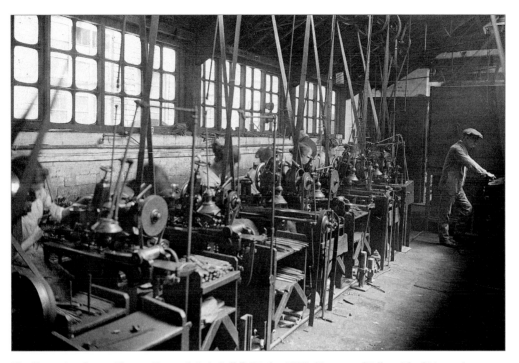

The file cutting shop at Thomas Turner & Co.'s Suffolk Works, 1902. (*Courtesy of Kelham Island Museum*)

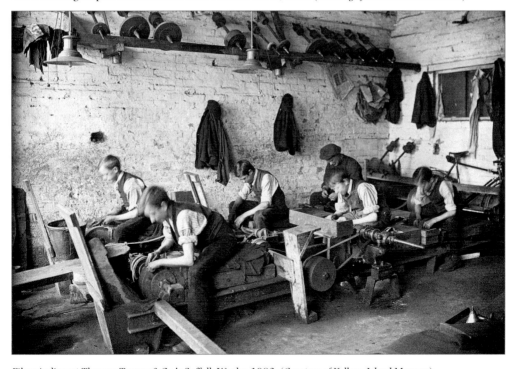

File grinding at Thomas Turner & Co.'s Suffolk Works, 1902. (*Courtesy of Kelham Island Museum*)

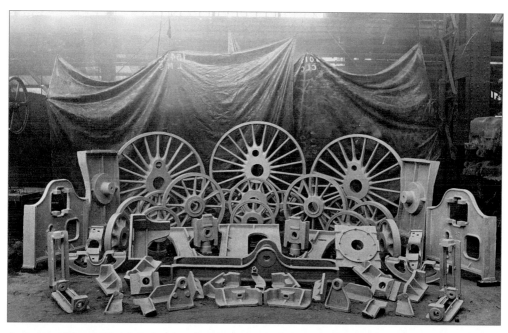

A selection of Cammell Laird steel castings for locomotives, including wheel centres and frame and motion parts, early 1900s. (*Courtesy of Kelham Island Museum*)

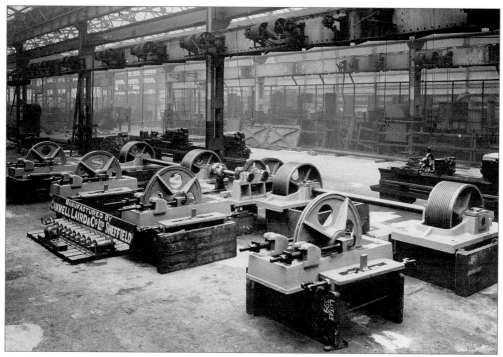

A selection of cast steel hoist sheaves and drums, base plates and bearings, rollers, gears and pinions at Cammell Laird's, early 1900s. (*Courtesy of Kelham Island Museum*)

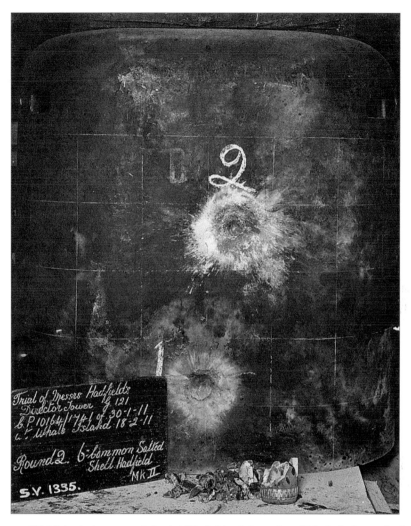

On 30 January 1911 firing tests were carried out at Whale Island. A number of 6-inch shells were fired at armour-plating manufactured by Messrs Hadfields and intended for use by the navy. The results of two hits can be seen here, with the spent shells at the bottom. A relative of Sir John Brown, the Sheffield steel magnate, Robert Hadfield (1832–88) opened a steel foundry in Newhall Road, Attercliffe, and named it the Hecla Works. His son Sir Robert Hadfield (1858–1940, knighted in 1908) joined his father in the business. Having conducted experiments for several years, at the age of just twenty-four he made a major discovery when his experiments showed that steel with a 12½ per cent manganese content hardened with use. Hadfield's experiments and discoveries created a new branch of steelmaking in Sheffield and to this day the production of special steels has kept Sheffield at the forefront of steelmaking. On his father's death in 1888 Robert Hadfield became chairman of the company and developed Hadfields into one of largest steel producing companies in the United Kingdom, and the company became a major producer of shells and other armaments. Expansion on the scale necessary for this rapidly growing company was not possible on the Newhall Road site, so he set about building a new works in Tinsley in 1897, which he named the East Hecla Works. By 1919 Hadfields had become Sheffield's largest employer with a workforce of over fifteen thousand. During the twentieth century Hadfields continued to be a major employer of Sheffield's steelworkers, although the company was subject to a series of takeovers. Production continued at East Hecla until 1982, when the works closed. The site of Hadfields' East Hecla Works is now occupied by the Meadowhall Shopping Centre. (*Courtesy of Kelham Island Museum*)

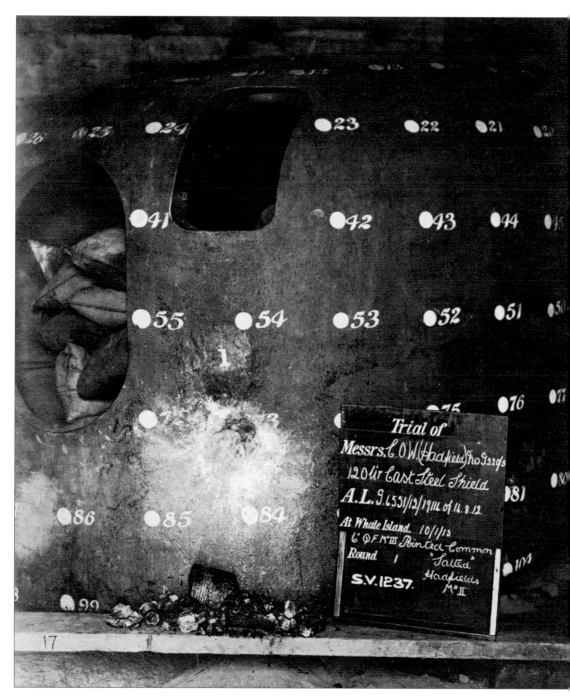

Tests conducted on cast steel products manufactured by Hadfields at Whale Island, 10 January 1911. Spent shells that have been fired at the gun turret can be seen at the bottom of the photograph, with the damage caused above.
(*Courtesy of Kelham Island Museum*)

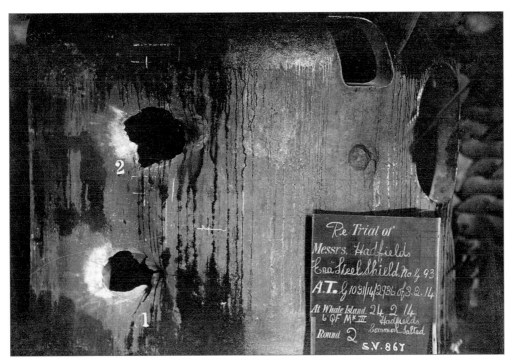

Tests conducted on a steel shield manufactured at Hadfields, 24 February 1914. The damage caused can be clearly seen. (*Courtesy of Kelham Island Museum*)

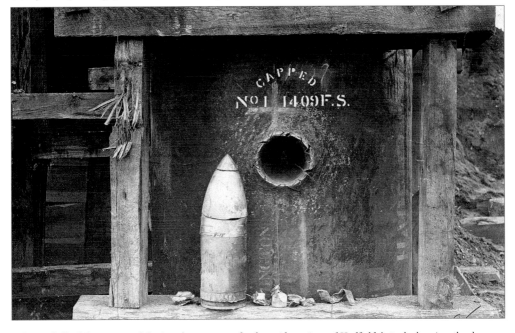

A large shell of the type used during the tests stands alongside a piece of Hadfields' steel, showing the damage caused during tests conducted in the run-up to the First World War. (*Courtesy of Kelham Island Museum*)

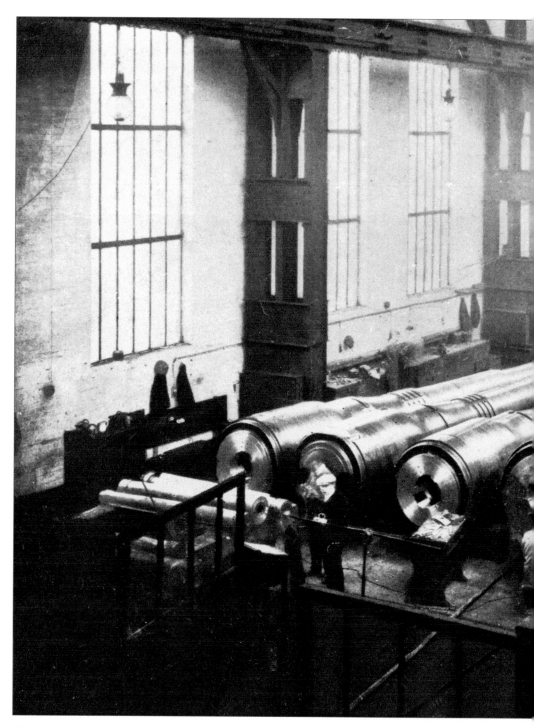

The gun examining bay in the south gun shop at Vickers, Son & Maxim's River Don Works, pictured early in the twentieth century. (*Courtesy of Kelham Island Museum*)

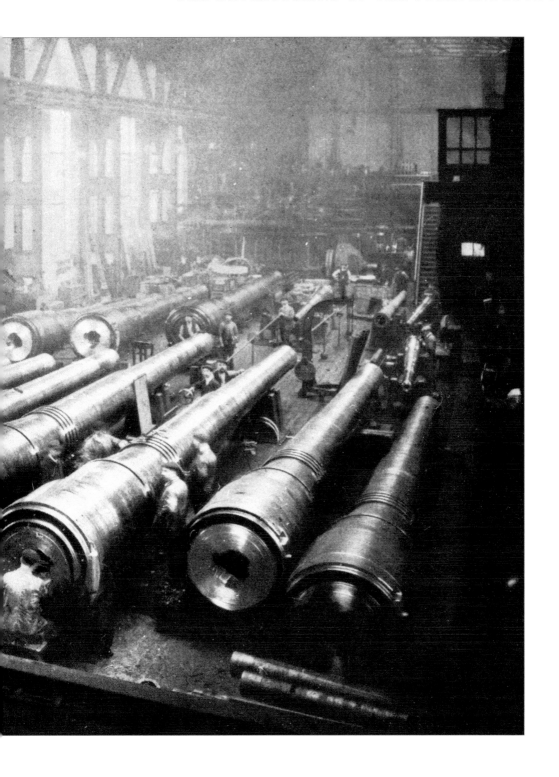

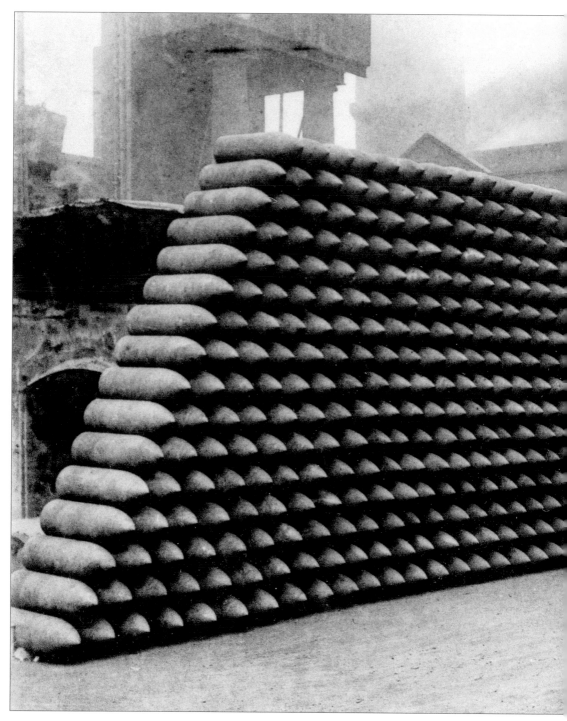

A stack of 9.2-inch armour-piercing shell forgings, pictured at Firth's during the First World War. (*Courtesy of Kelham Island Museum*)

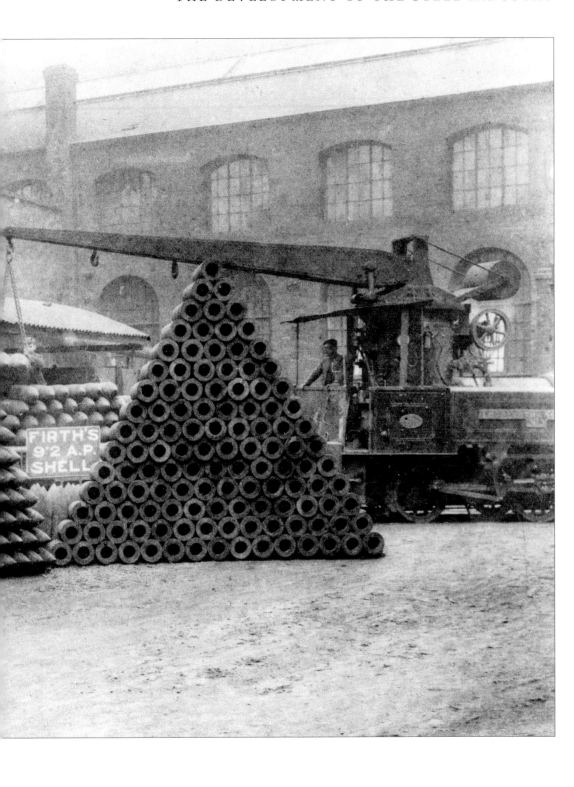

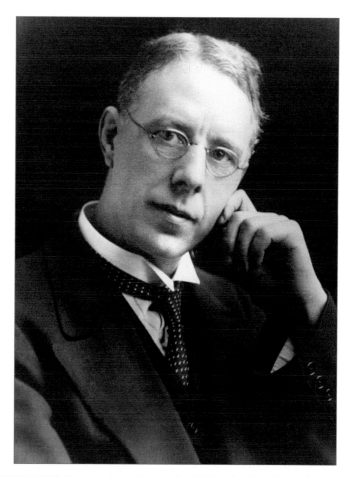

Harry Brearley (1871–1948) discovered stainless steel in 1913 when he was working in the Brown Firth Research Laboratories. The companies created by John Brown and Thomas Firth set up joint research laboratories in 1908, in a purpose-built block in Princess Street. Harry Brearley was put in charge. During his research on steels for gun barrels Brearley conducted tests on low-carbon steels containing only 12 per cent chromium. These steels, he discovered, were resistant to corrosion and remained unstained by food acids. The commercial implications of this discovery, which he originally called 'rustless steel', soon became evident, particularly in the cutlery industry, although the cutlers were reluctant at first to believe that the existence of such a steel was possible. The name 'rustless steel' did not catch on, nor did another suggestion 'Rusnorstain', but 'stainless steel' did. A dispute arose over who owned the rights to Brearley's invention and this eventually resulted in Brearley leaving Firth's. He was offered a position at Brown Bayleys as works manager, on his own terms, and soon after taking up the appointment he became a director. After protracted legal wrangling and court cases regarding foreign patents for stainless steel, a compromise was eventually reached with Firth's which was advantageous to both parties. Firth's marketed the stainless steel produced by themselves from 1923 as 'Staybrite' steel. (*Courtesy of Kelham Island Museum*)

Staybrite Steel

Advertising sign for Staybrite steel at the Staybrite Works, Weedon Street, Tinsley, 1930s. Originally known as Tinsley Works, it was renamed in the 1920s after Firth's brand name for stainless steel. (*Courtesy of Kelham Island Museum*)

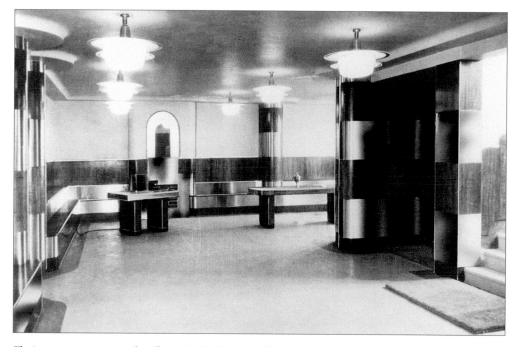

The impressive entrance to the offices at Firth's Staybrite Works, as it appeared in the 1920s. The use of Staybrite steel in the fixtures and fittings creates an impressive display for visitors at the works. Staybrite, Firth's own brand of corrosion-resistant steel, was developed by W.H. Hatfield in 1923. It contained 18 per cent chromium and 8 per cent nickel. An enormous market opened up for Firth's Staybrite steel products. The chemical industry used Staybrite extensively, as did the brewing industry. Smaller products included kitchen sinks, fish fryers, cocktail shakers, letter boxes, surgical equipment and, of course, cutlery. Staybrite steel also become a popular feature in art deco influenced buildings, both inside and out. (*Courtesy of Kelham Island Museum*)

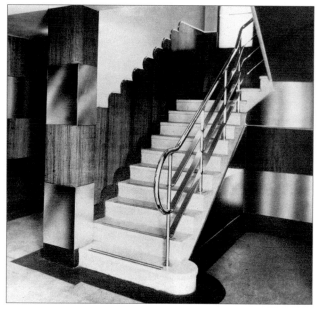

The main staircase at the Staybrite Works. The Firth Brown Company was formed in 1930 when Thomas Firth & Sons and John Brown & Co. amalgamated. In 1934 Staybrite steel products were used extensively in the building of the *Queen Mary*. Later that year a new company was formed, Firth-Vickers Stainless Steels Limited, by equal partners Firth Brown and the English Steel Corporation Ltd. (*Courtesy of Kelham Island Museum*)

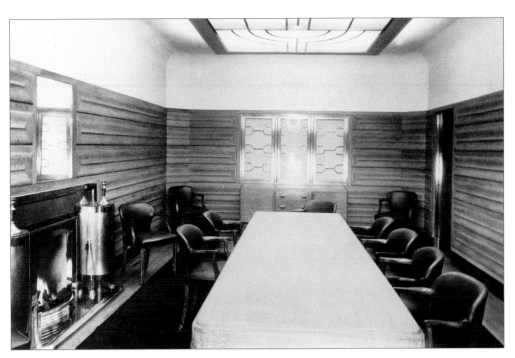

The board room and (below) the reception room at Firth's Staybrite Works, as they were in the 1920s. (*Courtesy of Kelham Island Museum*)

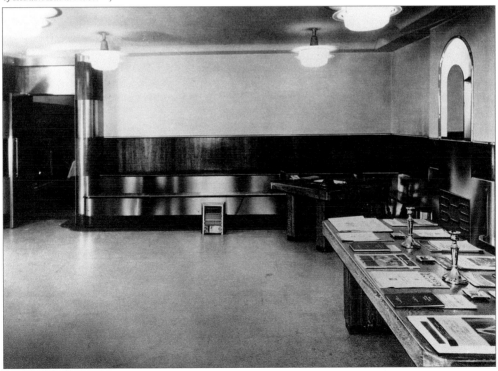

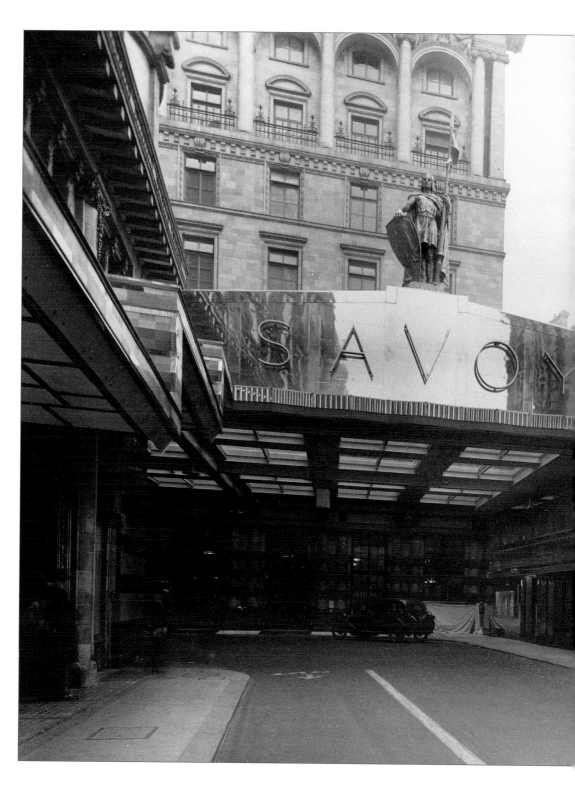

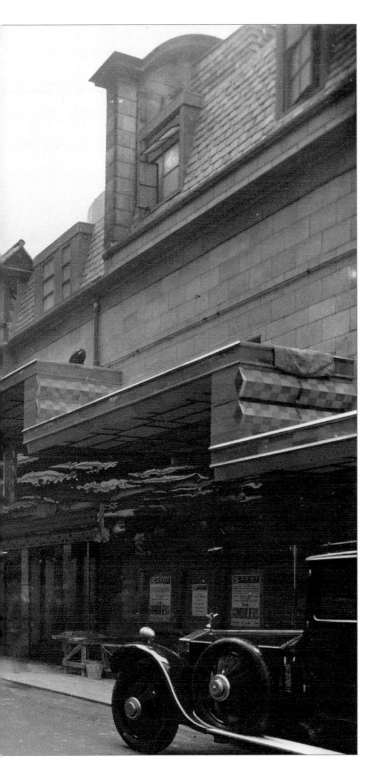

A view of the entrance to London's Savoy Hotel in Savoy Place, the Strand, shortly after alterations were made to the hotel by Easton & Robertson in 1929. Staybrite steel was used for the entrance canopy above the portal. The canopy is still in pristine condition at the beginning of the twenty-first century. The hotel was built in 1903 from the profits of the Savoy Theatre (right), which was built to the designs of C.J. Phipps and opened in 1881. (*Courtesy of Kelham Island Museum*)

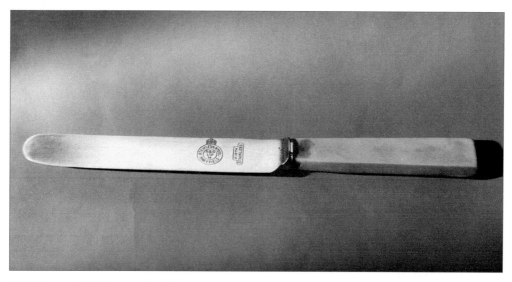

A Staybrite steel knife, pictured in the 1920s after being buried in a compost-heap for two years! (*Courtesy of Kelham Island Museum*)

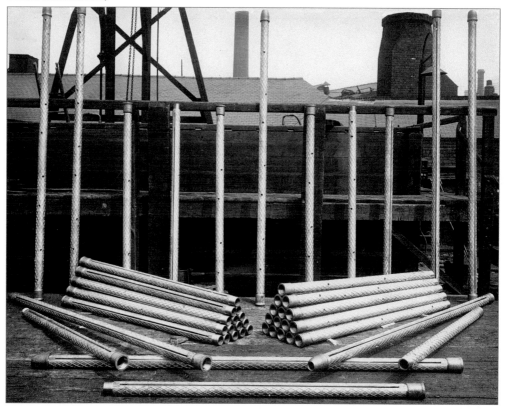

Staybrite steel tubes made for the Aswan Dam, constructed in southern Egypt near the city of Aswan. Construction began in 1960. (*Courtesy of Kelham Island Museum*)

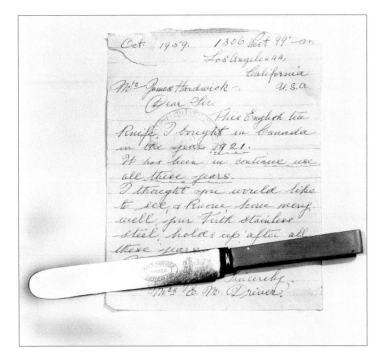

In October 1959 Mrs E.M. Driver from California wrote to James Hardwick at Messrs Vickers, enclosing a knife made from Staybrite steel. Her letter said that she had purchased the knife in Canada in 1921 and that it had been in constant use for nearly forty years! (*Courtesy of Kelham Island Museum*)

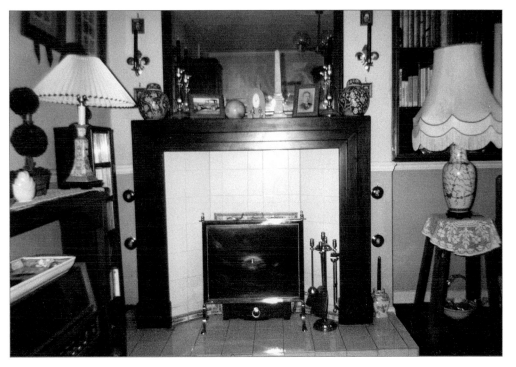

This photograph, taken in June 2001, shows a Staybrite steel firescreen and companion set, formerly the property of Nancy, Lady Astor (1879–1964), and now at the London home of the author. (*Author's collection*)

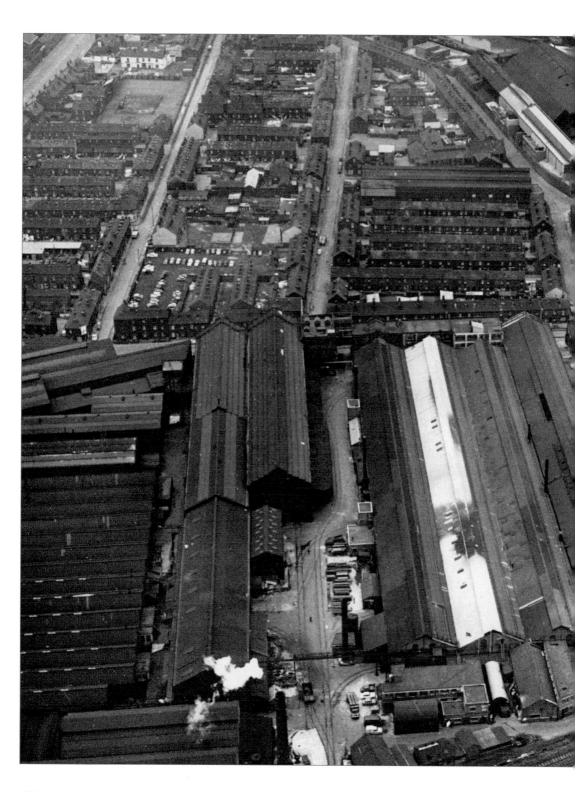

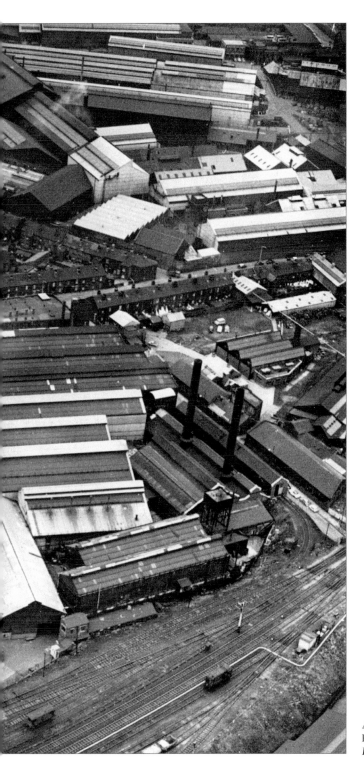

Aerial view of the Weedon Street site of
Firth-Vickers, 1960s. (*Courtesy of Kelham
Island Museum*)

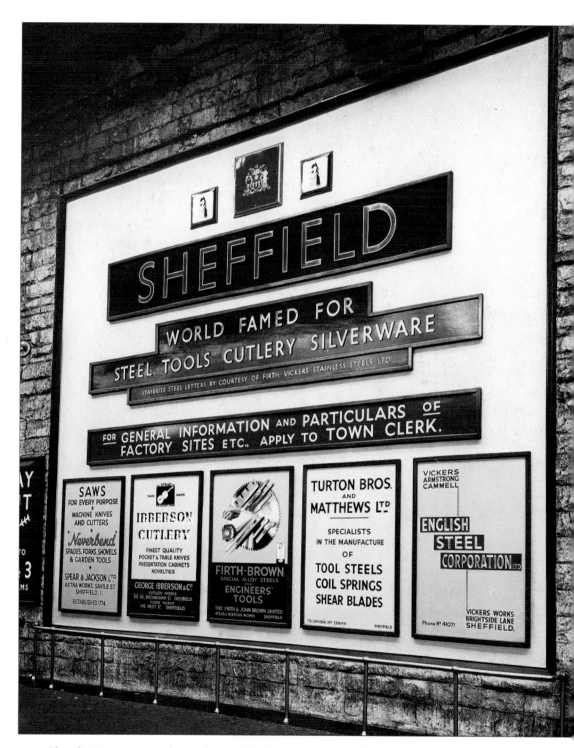

This advertisement appeared on Sheffield's LNER Victoria station in the 1930s. (*Courtesy of Kelham Island Museum*)

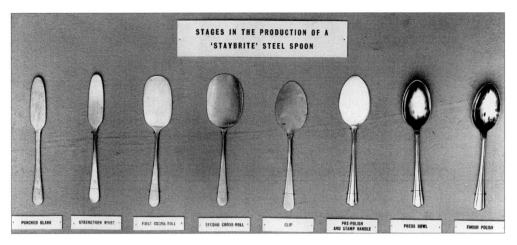

STAGES IN THE PRODUCTION OF A 'STAYBRITE' STEEL SPOON

PUNCHED BLANK · STRENGTHEN WAIST · FIRST CROSS-ROLL · SECOND CROSS-ROLL · CLIP · PRE-POLISH AND STAMP HANDLE · PRESS BOWL · FINISH POLISH

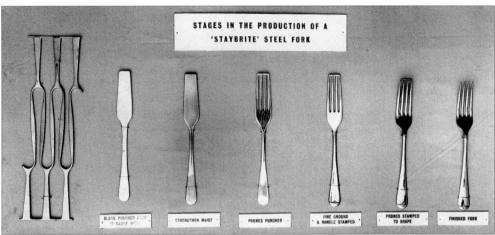

STAGES IN THE PRODUCTION OF A 'STAYBRITE' STEEL FORK

BLANK PUNCHED FROM GAUGE STRIP · STRENGTHEN WAIST · PRONGS PUNCHED · FINE GROUND & HANDLE STAMPED · PRONGS STAMPED TO SHAPE · FINISHED FORK

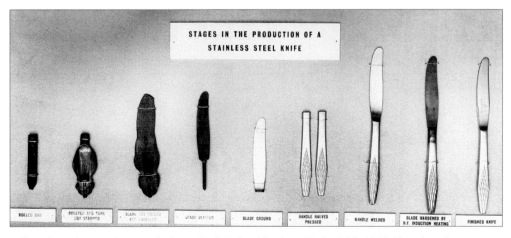

STAGES IN THE PRODUCTION OF A STAINLESS STEEL KNIFE

ROLLED BAR · BOLSTER AND TANG END STAMPED · BLADE AND BOLSTER END STAMPED · BLADE CLIPPED · BLADE GROUND · HANDLE HALVES PRESSED · HANDLE WELDED · BLADE HARDENED BY H.F. INDUCTION HEATING · FINISHED KNIFE

These three photographs were all taken at Firth-Vickers' Staybrite Works, 5 July 1962. They show the stages in the production of a spoon (top), a fork (middle) and a knife (bottom). (*All by courtesy of Kelham Island Museum*)

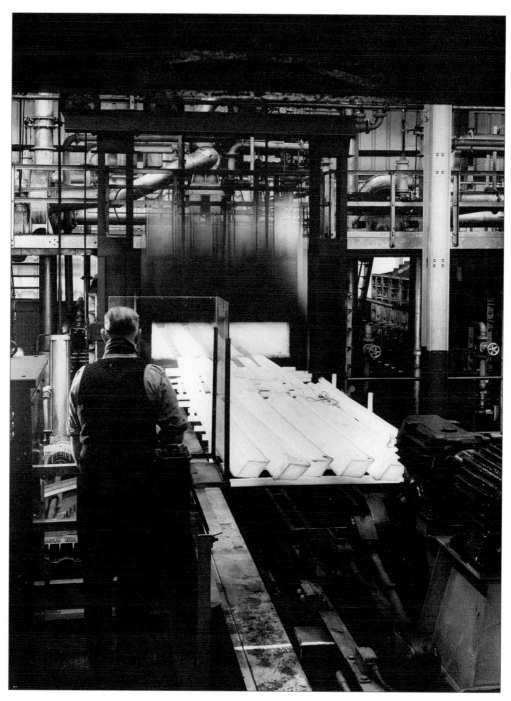

Withdrawing bars from the treatment furnace at Firth-Vickers' Staybrite Works, Weedon Street,
8 December 1961. (*Courtesy of Kelham Island Museum*)

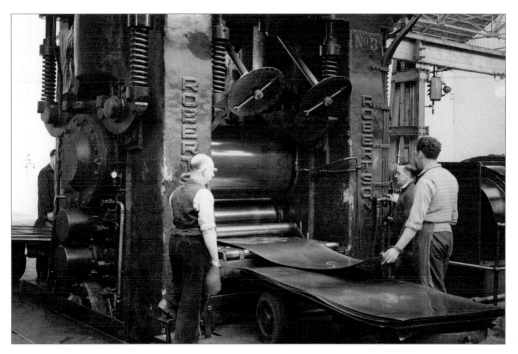

Cold rolling sheets of Staybrite steel on the Robertson cold rolling mill at Firth-Vickers' Staybrite Works, 1963. (*Courtesy of Kelham Island Museum*)

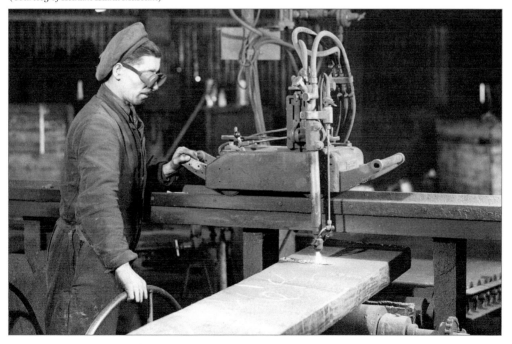

Oxyacetylene cutting of Staybrite stainless steel at Firth-Vickers' Staybrite Works, 1963. (*Courtesy of Kelham Island Museum*)

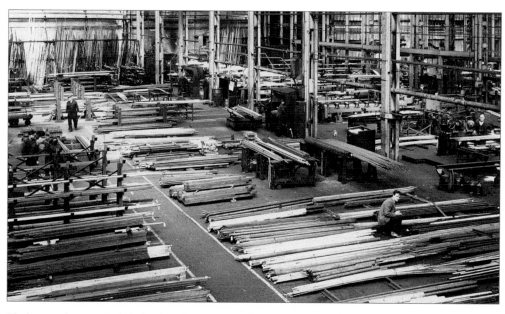

The bar warehouse at Firth-Vickers' Staybrite Works, 1963. (*Courtesy of Kelham Island Museum*)

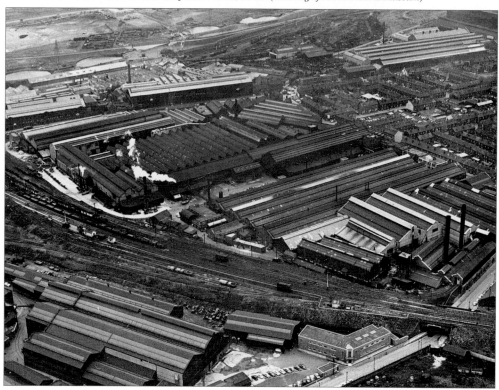

An aerial view of Firth-Vickers' Staybrite Works in Weedon Street and Firth Derihon Stampings Ltd, 1950s. (*Courtesy of Kelham Island Museum*)

The last sheet of Staybrite steel being removed from the furnace at Firth-Vickers' Staybrite Works, Weedon Street, 26 August 1966. (*Courtesy of Kelham Island Museum*)

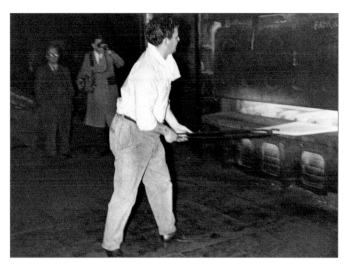

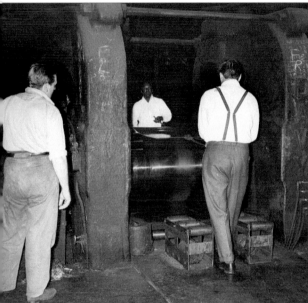

Rolling the last sheet of Staybrite steel on the mills at Firth-Vickers' Staybrite Works, 26 August 1966. (*Courtesy of Kelham Island Museum*)

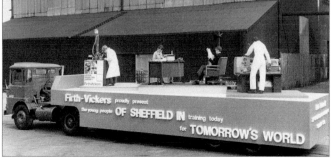

The Firth-Vickers' float in Sheffield's Lord Mayor's Parade, 1969. (*Courtesy of Kelham Island Museum*)

The Firth-Vickers' display in the cathedral church of St Peter and St Paul, Sheffield, 19 July 1969.
(*Courtesy of Kelham Island Museum*)

A Tour through the Steelworks

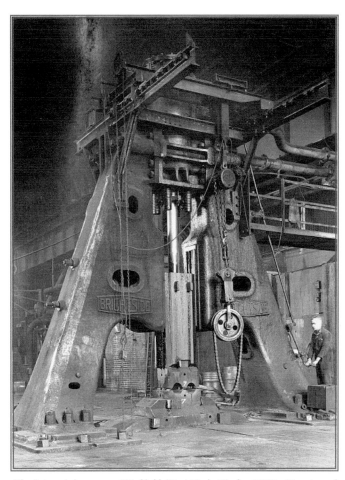

The 5-ton air hammer at Hadfields' East Hecla Works, 1950s. (*Courtesy of Kelham Island Museum*)

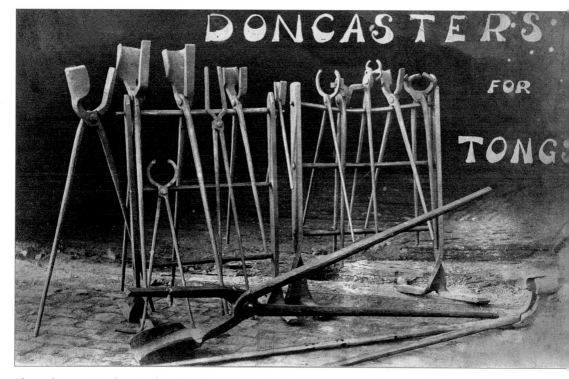

This early promotional postcard, produced in the late nineteenth century or early twentieth century, advertised steel tong produced by Daniel Doncaster & Sons Ltd. Daniel Doncaster began producing steel in the works he created in his father orchard in 1831. His father, also called Daniel Doncaster, was granted a trade mark by the Cutlers' Company in 1778. (*Courtes of Kelham Island Museum*)

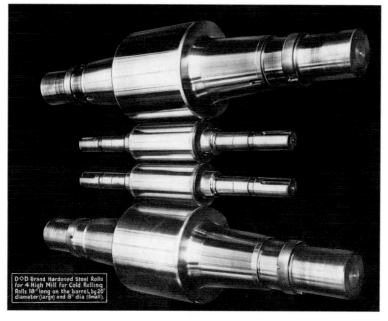

Hardened steel rolls for cold milling, manufactured by Daniel Doncaster & Sons Ltd. Note the distinctive company logo, the double D with a diamond motif between, used by Doncaster's since 1778. (*Courtesy of Kelham Island Museum*)

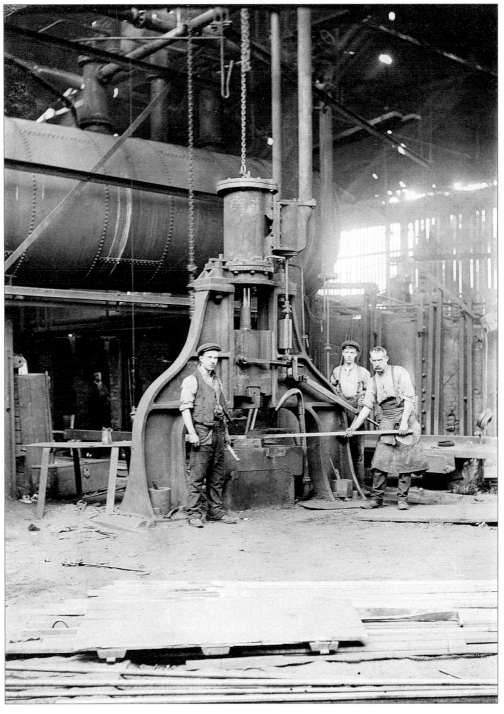

A steam hammer at Daniel Doncaster & Sons Ltd, early 1900s. The hammer man is P. Trent, the second man Mr Murgatroyd and the driver Mr Wilson. (*Courtesy of Kelham Island Museum*)

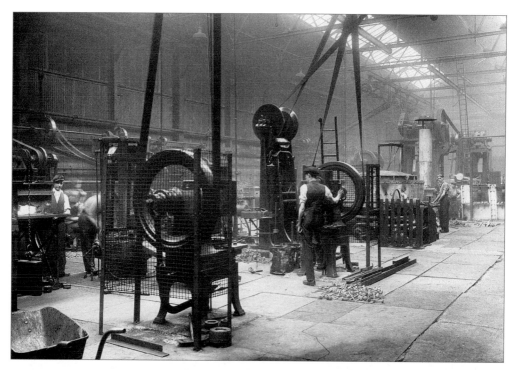

A general view of the hammer shop at Daniel Doncaster & Sons Ltd, *c.* 1910. (*Courtesy of Kelham Island Museum*)

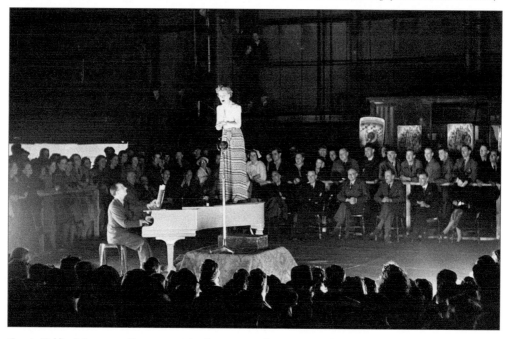

Gracie Fields giving a wartime concert in the armour-plate erection shop at Daniel Doncaster & Sons Ltd, 1 August 1941. (*Courtesy of Kelham Island Museum*)

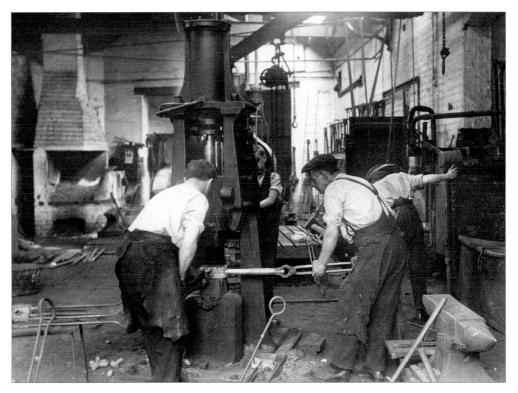

Work in progress at Daniel Doncaster & Sons Ltd in the 1950s. (Top): the drop hammer; (below): heat treatment of alloyed steel shafts. (*Courtesy of Kelham Island Museum*)

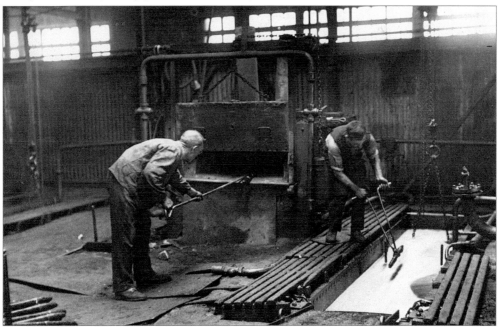

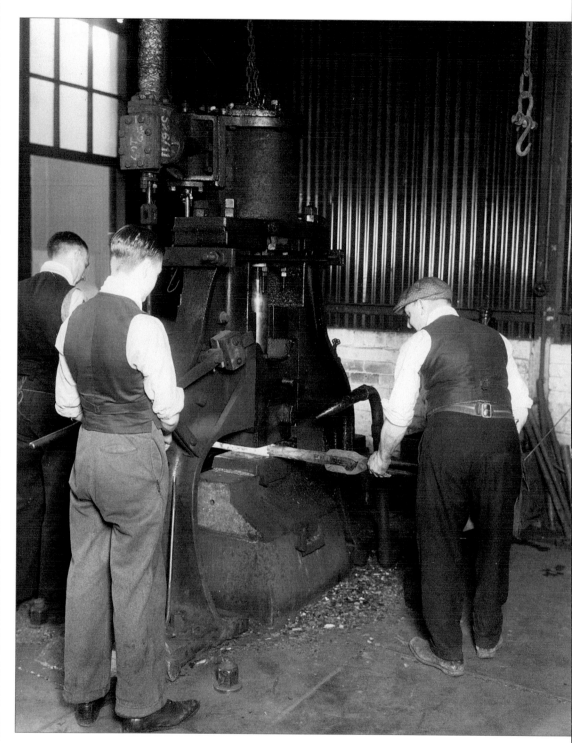

The forging hammer at Daniel Doncaster & Sons Ltd, 1950s. (*Courtesy of Kelham Island Museum*)

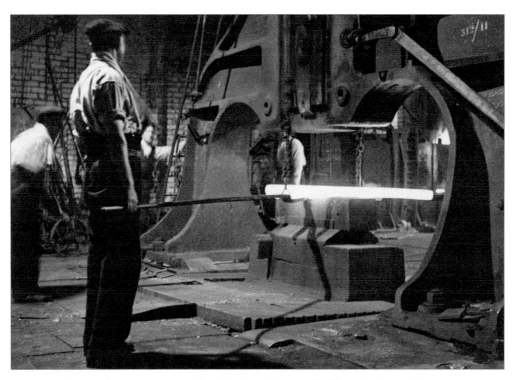

Forging steel at Daniel Doncaster & Sons Ltd in the 1950s. (*Courtesy of Kelham Island Museum*)

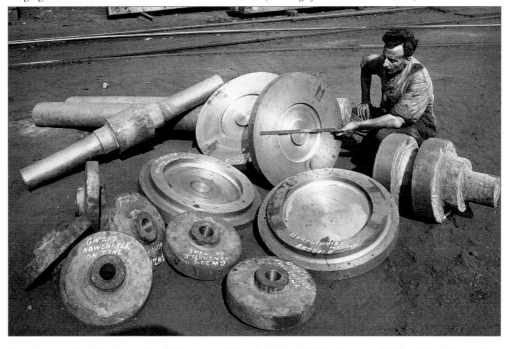

Gauging gear-blank forgings at Daniel Doncaster & Sons Ltd in the 1950s. (*Courtesy of Kelham Island Museum*)

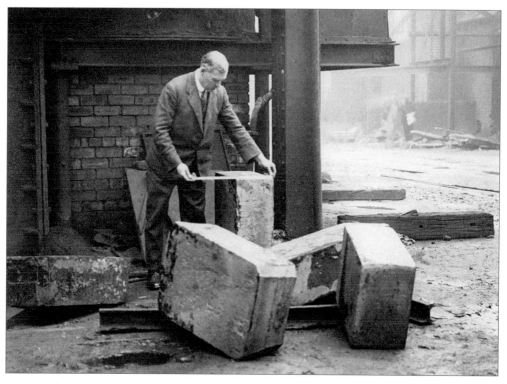

Inspecting die blocks at Daniel Doncaster & Sons Ltd, 1950s. (*Courtesy of Kelham Island Museum*)

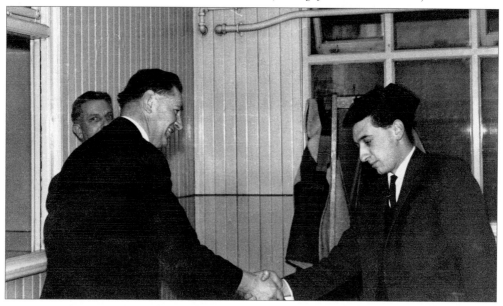

The presentation of awards for Daniel Doncaster & Sons' further education programme for 1963–4. The presentation took place on 2 March 1965, and here we see Mr R.D. Steel receiving his award from Mr R.T. Doncaster. (*Courtesy of Kelham Island Museum*)

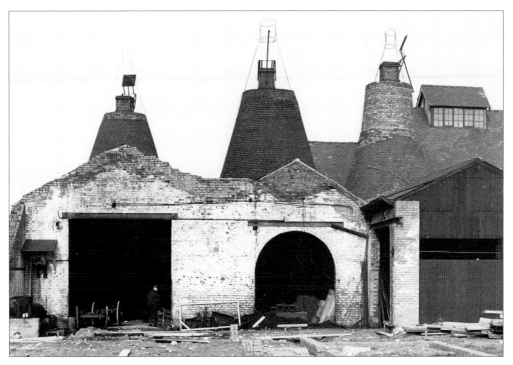

Cementation furnaces nos 2, 4 and 5 at Daniel Doncaster & Sons' Doncaster Street Works, April 1951. This photograph shows the modifications that took place after damage caused by the 'Sheffield Blitz' during December 1940. (*Courtesy of Kelham Island Museum*)

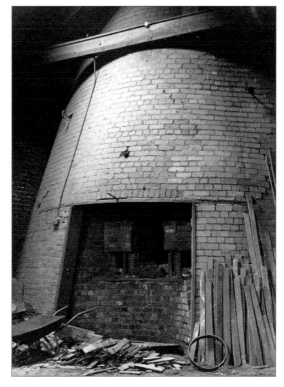

A closer view of one of the cementation furnaces at the Doncaster Street Works, April 1951. (*Courtesy of Kelham Island Museum*)

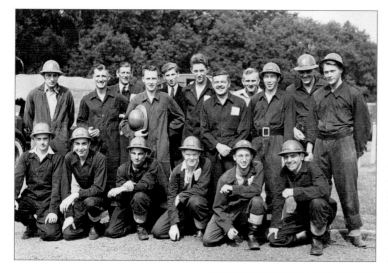

The fire-fighting team at Newton Chambers & Co. Ltd, late 1950s. Back row, left to right: Roy Mansfield, Alan Hewling, -?-, -?-, -?-, Brian Wadsworth, Ben Morton, Cliff Jubb, Albert Philips, -?-, -?-. Front row: -?-, Harold Short, -?-, Eric Almond, Gordon Hindley, Ernest Wood. (*Courtesy of Harold Short*)

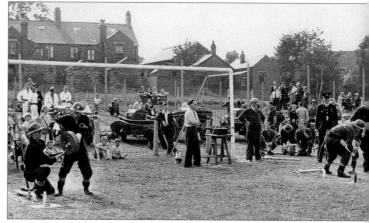

The Newton Chambers fire-fighting team giving a demonstration in the late 1950s. (*Courtesy of Harold Short*)

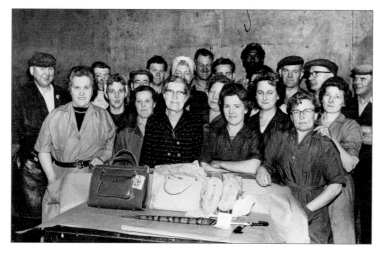

Core makers at Newton Chambers & Co. Ltd, Thorncliffe Works, pictured at a presentation on the occasion of the retirement of Mrs Johnson of High Green in 1962. Mrs Johnson is front centre, wearing spectacles. Also featured in the photograph are Gwen Sinfield (née Hewitt), Annie Buxton (née Walton), Jacqueline Lawton (née Walton), Vera Eagle (née Dyson), Nellie Armitage, Bobby Royston and Myrtle Padley. (*Courtesy of Doreen Nowak*)

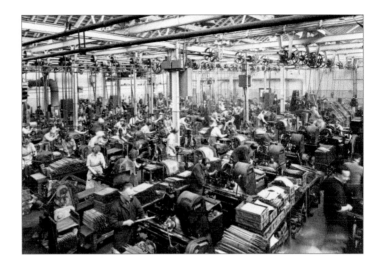

The Holme Lane file works of the English Steel Corporation Ltd, Malin Bridge, 1950. (*Courtesy of Kelham Island Museum*)

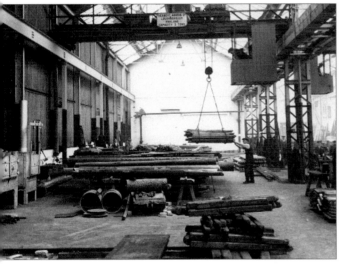

The warehouse at William Jessop & Sons' Brightside Works, 1940s. At this time L. Stainforth (1888–1976) was warehouse manager. Jessop's was established in Sheffield in 1774. Originally located in central Sheffield, the company moved to Brightside in the 1820s, being the first firm to colonise the area, its works then being known as the Brightside Works. By the beginning of the twentieth century Brightside presented an almost unbroken series of steelworks for a distance of over 2 miles. (*Courtesy of Kelham Island Museum*)

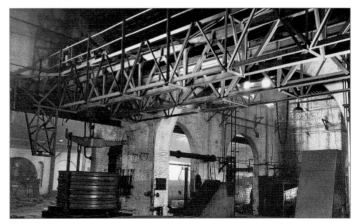

Brown Bayley's electric tyre heat treatment plant, 26 February 1935. (*Courtesy of Kelham Island Museum*)

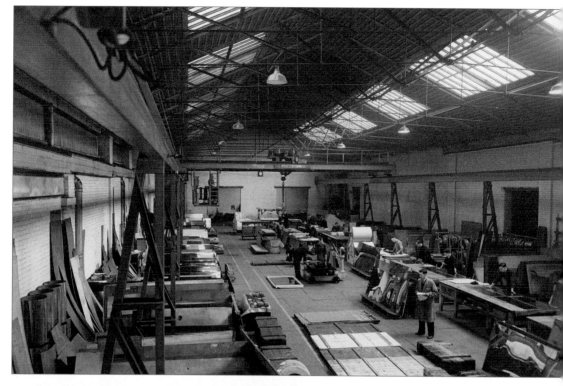

Brown Bayley's Steelworks Ltd, Attercliffe. This 1960s view shows the stainless steel sheet warehouse. (*Courtesy of Kelham Island Museum*)

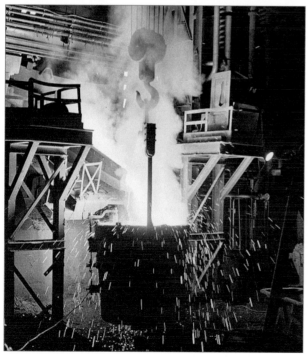

Sparks fly as molten blast furnace metal is poured into the mould at Brown Bayley's Steelworks, 28 May 1968. (*Courtesy of Kelham Island Museum*)

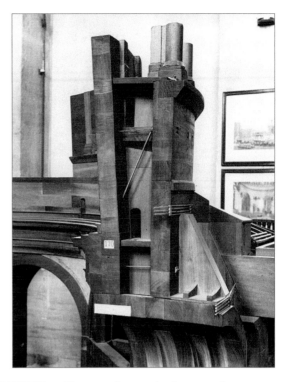

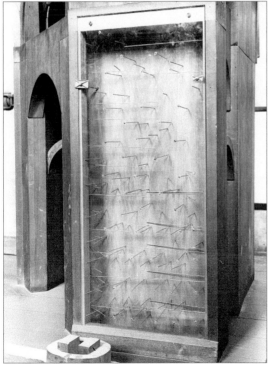

These two photographs show part of a wooden model of St Paul's Cathedral, London, photographed on 10 July 1962. In the top photograph can also be seen a scale model of the stainless steel girdles manufactured by Brown Bayleys and installed in London's St Paul's Cathedral, while in the bottom photograph can be seen the stainless steel pins manufactured by Brown Bayleys and encased in concrete, and also installed in St Paul's. (*Both by courtesy of Kelham Island Museum*)

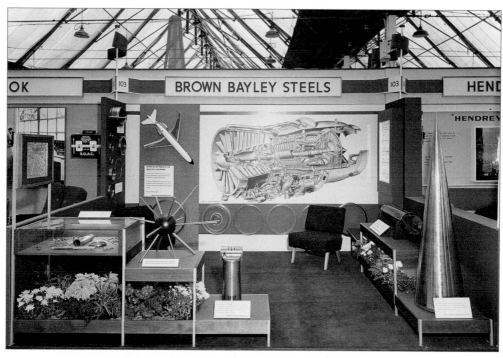

A trade stand for Brown Bayley Steels, 1964. (*Courtesy of Kelham Island Museum*)

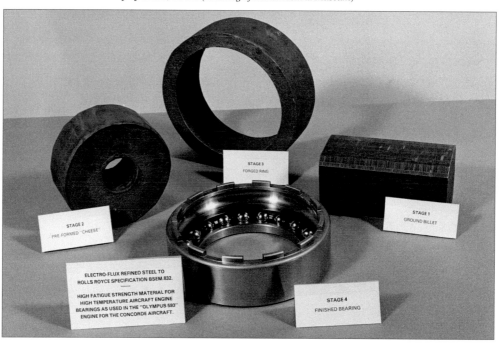

Brown Bayley Steels, 1972. Four stages in the manufacture of the main thrust bearing of a Rolls-Royce aircraft engine. (*Courtesy of Kelham Island Museum*)

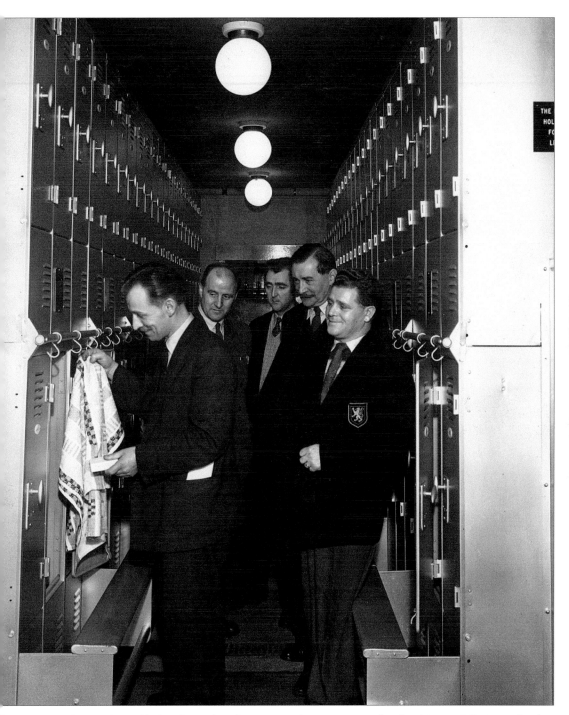

The opening of the new shower block at the Monk Bridge Iron & Steel Company on Wednesday, 14 May 1958. Featured in the photograph (from left to right) are: Mr J. Walsh (screw press operator), Mr St John Binns (district secretary AEU), Mr B. Blomley (labour manager), Mr R. Steel (chairman) and Mr R. McWilliam (maxi-press operator). (*Courtesy of Kelham Island Museum*)

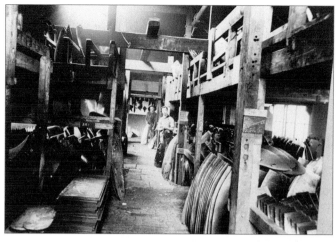

Three views of work in progress at Tyzack
Sons & Turner's Little London Works, 1950s.
(Top): prepared steel blades for scythe-making;
(middle): making circular saw blades; (bottom):
file making. (*All by courtesy of Kelham Island
Museum*)

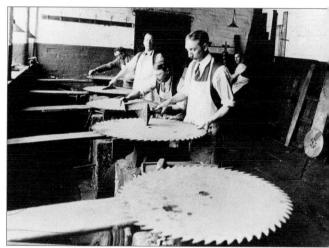

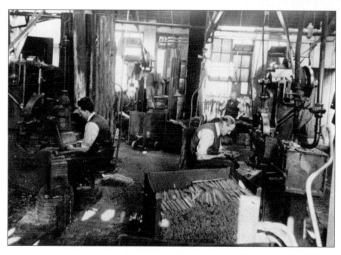

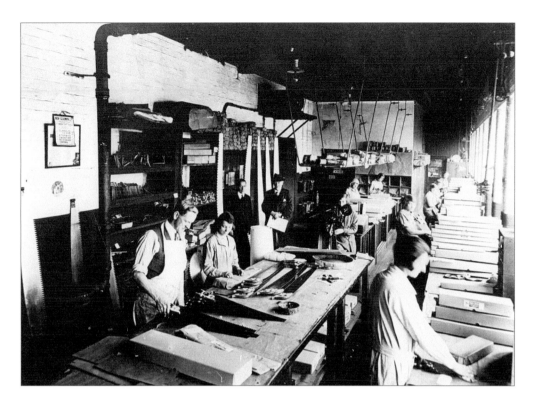

Packing saws for dispatch at Tyzack Sons & Turner's, 1950s. (*Courtesy of Kelham Island Museum*)

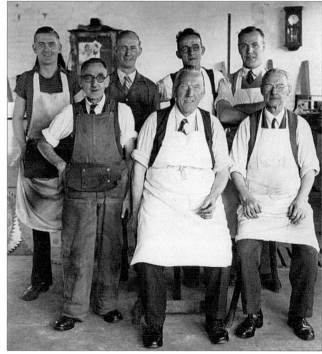

Sawmakers at the Little London Works, *c.* 1950. Back row, left to right: Leslie Bennett, Alf Linley, Harry Young, Stanley (Bud) Wainman. Front row: Joe Price, Billy Hance, Harry Young (senior). (*Courtesy of Kelham Island Museum*)

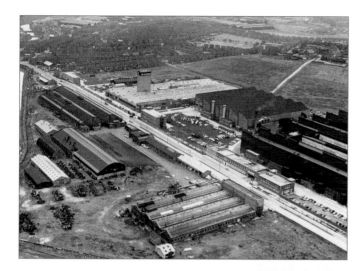

Aerial view of Firth-Vickers and Shepcote Lane rolling mills, 17 July 1963. (*Courtesy of Kelham Island Museum*)

The hot line at Shepcote Lane rolling mills, 1960s. (*Courtesy of Kelham Island Museum*)

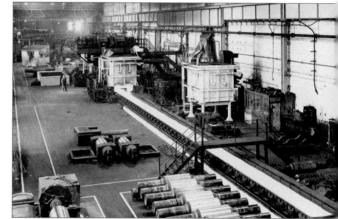

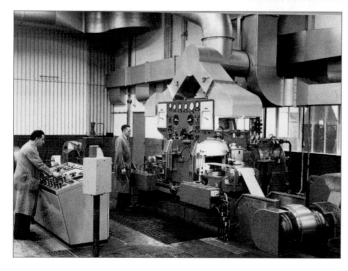

The narrow strip mill at Shepcote Lane, 1960s. (*Courtesy of Kelham Island Museum*)

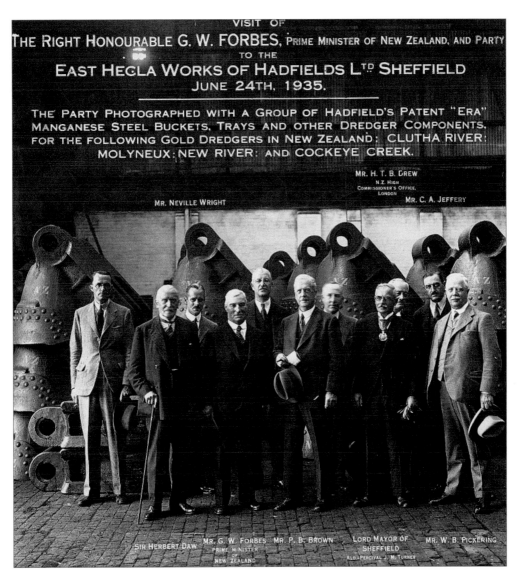

Officials and staff at Hadfields, 24 June 1935. (*Courtesy of Kelham Island Museum*)

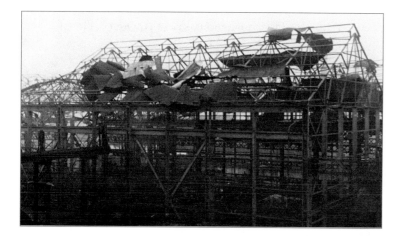

Landmine damage inflicted on Hadfields no. 6 machine shop, East Hecla Works on Sunday, 15 December 1940, during the 'Sheffield blitz'. This photograph was taken a week later, on 23 December 1940. (*Courtesy of Kelham Island Museum*)

Landmine damage inflicted on Hadfields' no. 3 hardening shop, East Hecla Works, also photographed on 23 December 1940. (*Courtesy of Kelham Island Museum*)

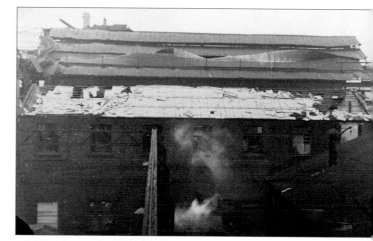

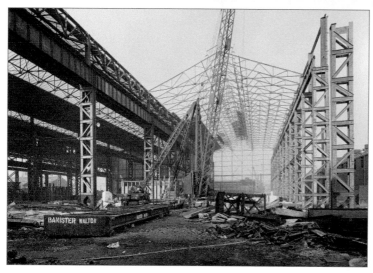

The new centralised forge under construction at East Hecla Works, 1 November 1950. (*Courtesy of Kelham Island Museum*)

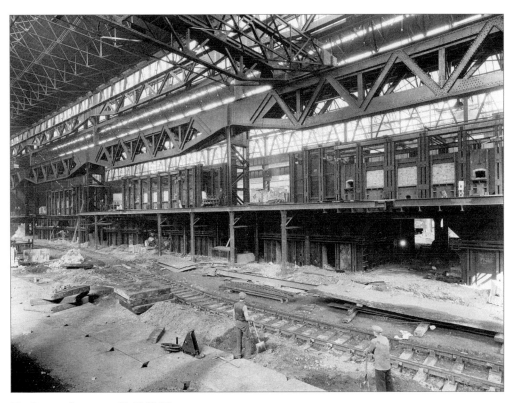

The Siemens furnaces at Hadfields' East Hecla Works, viewed from the casting bay, 17 March 1933. Siemens steel was developed by Sir William Siemens (1822–83) in South Wales and went into commercial production in 1870. Cast iron and scrap material were melted in an open hearth, forming a slag to which iron ore was added. The carbon was burnt off and the resulting iron converted to steel. Although slower than the Bessemer process, this method produced a better-quality steel. Siemens steel found many uses in the manufacture of guns and in special forgings for ship building and engineering. (*Courtesy of Kelham Island Museum*)

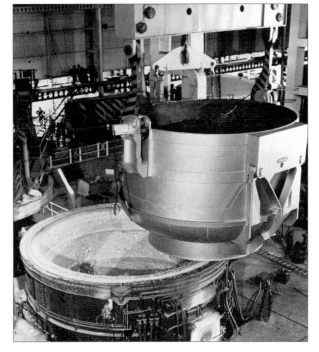

Charging an electric arc furnace at Steel, Peach & Tozer, 1963. (*Courtesy of Kelham Island Museum*)

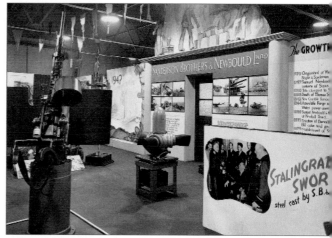

The Princess Royal visited the works of Sanderson Brothers & Newbould Ltd on 27 March 1944, for which occasion a special exhibition was mounted. These three photographs show some of the exhibition stands demonstrating the wide range of products produced by the company. (*Courtesy of Kelham Island Museum*)

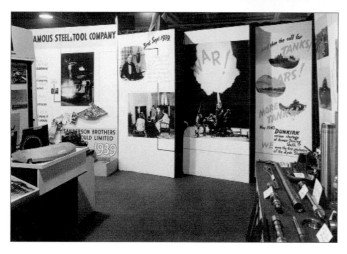

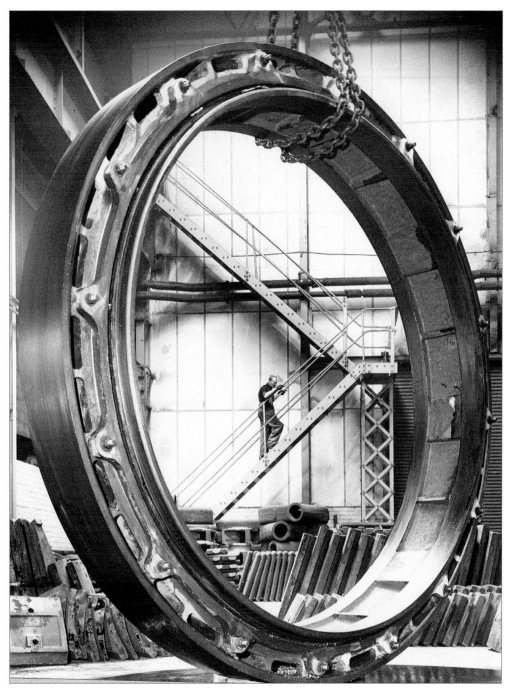

A machine shop at Thomas Firth & John Brown Ltd (more commonly known as Firth Brown), *c.* 1955. (*Courtesy of Kelham Island Museum*)

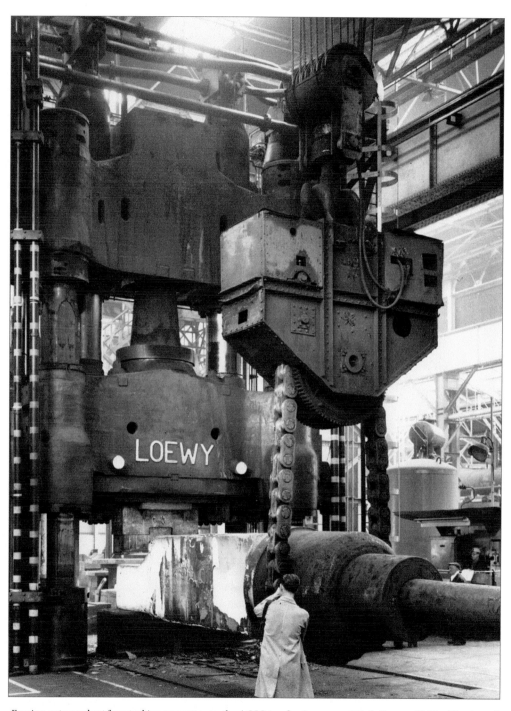

Forging a steam chest for a turbine generator on the 4,000-ton forging press at Firth Brown, 1960s. (*Courtesy of Kelham Island Museum*)

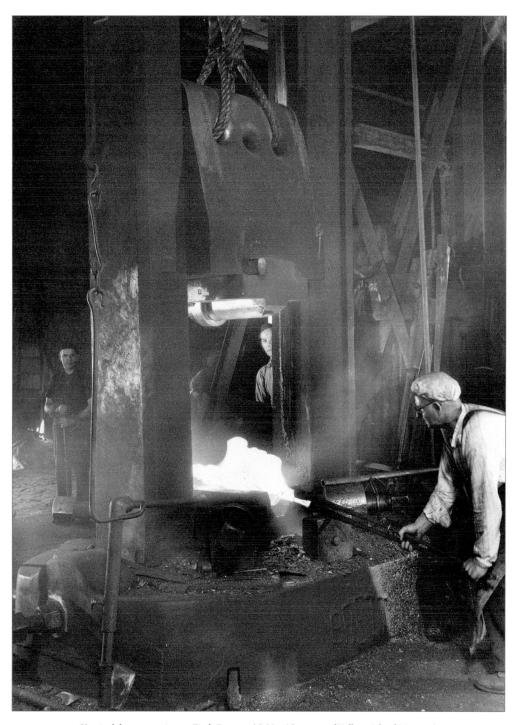

Vertical drop stamping at Firth Brown, 1960s. (*Courtesy of Kelham Island Museum*)

This Firth Brown exhibition stand proudly displayed a huge alternating shaft weighing 40 tons 19 cwts. It was produced for the English Electric Co. for use in Willington power station. (*Courtesy of Kelham Island Museum*)

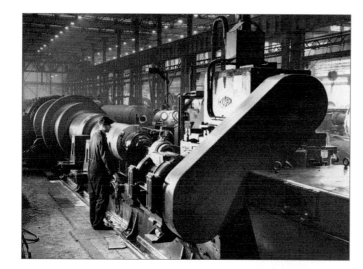

The 70-ton high flyer boring machine at Firth Brown, 1950s. (*Courtesy of Kelham Island Museum*)

The shaft and gun boring lathe at Firth Brown, *c.* 1955. (*Courtesy of Kelham Island Museum*)

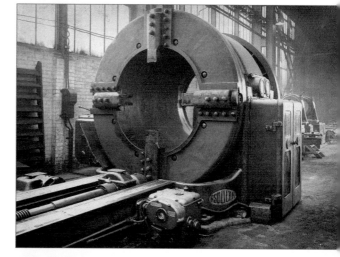

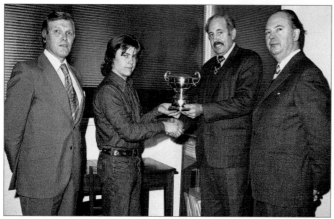

Engineering technician trainee Paul J. Stenton won the coveted Foreman's Bowl in 1978, and the presentation ceremony took place in A.E. Marshall's office at Firth Brown Tools Ltd on 4 December 1978. Left to right: Mr B. Thompson, Paul J. Stenton, Mr J. Bingham and Mr A.E. Marshall. (*Courtesy of Kelham Island Museum*)

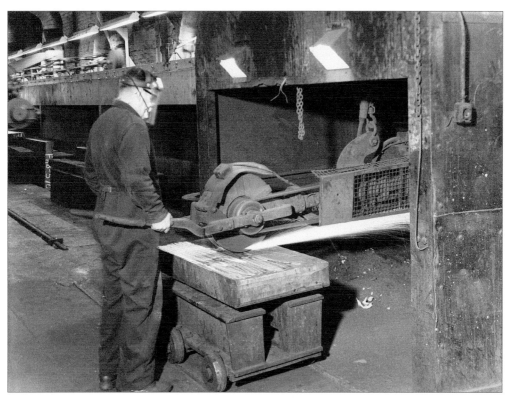

The grinding mill in operation at Shepcote Lane rolling mills, 1950s. (*Courtesy of Kelham Island Museum*)

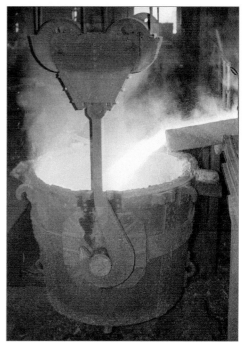

Tapping molten steel into a ladle at Samuel Fox's Stocksbridge Works, 14 June 1954. (*Courtesy of Kelham Island Museum*)

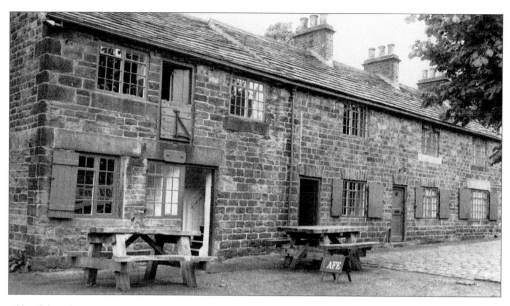

Abbeydale Industrial Hamlet, seen here in the 1980s, is situated on the River Sheaf, 4 miles from Sheffield city centre, between Beauchief and Dore. It dates from about 1714 and is believed to occupy the site of a sixteenth-century lead smelting works. The principal products manufactured at Abbeydale were scythes, peat cutters, grass hooks and various other agricultural and horticultural tools and implements. The works operated until 1933, when Tyzack Sons & Turner transferred operations to their Little London Works. Among the numerous interesting industrial artefacts still to be seen at Abbeydale is a five-hole crucible shop dating to about 1829. (*Courtesy of Sheffield Central Library*)

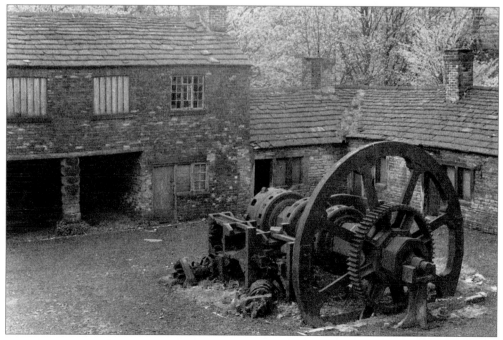

Workshops at Abbeydale Industrial Hamlet, seen here in the 1960s. (*Courtesy of Sheffield Central Library*)

The Cutlery Industry

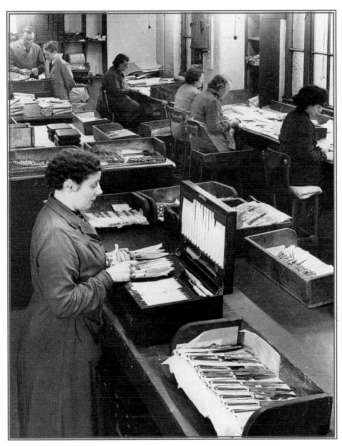

Women at work packing finished cutlery in the packing and polishing
room, Mappin & Webb, 6 January 1955. (*Courtesy of Kelham
Island Museum*)

Roscoe Head Wheel, off Rivelin Valley Road. Sheffield's cutlery industry grew because of the plentiful supply of raw materials and the abundance of water power from Sheffield's five rivers. The Roscoe Head Wheel made use of water from the River Rivelin. William Hoole rented this newly built wheel in 1725. It remained in operation until 1936. This photograph shows what remained on the site in about 1955. (*Courtesy of Kelham Island Museum*)

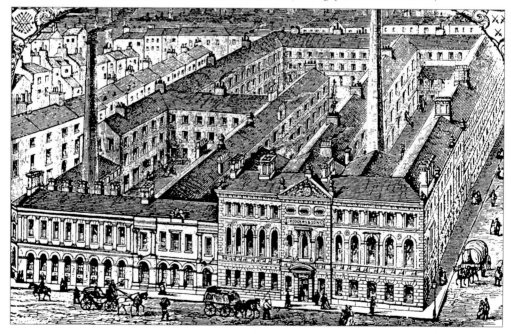

Joseph Rodgers' Cutlery Works moved to 6 Norfolk Street in about 1780. The firm originally produced penknives but by the time Joseph Rodgers died in 1821 (the year Joseph Rodgers & Sons was granted a royal warrant), leaving his four sons to run the business, the works was producing cutlery, razors and scissors. The firm's trademark of the six-pointed star and Maltese Cross became famous the world over. Rodgers' advertising slogan ran 'The King of knives and the knife of Kings'. (*Author's collection*)

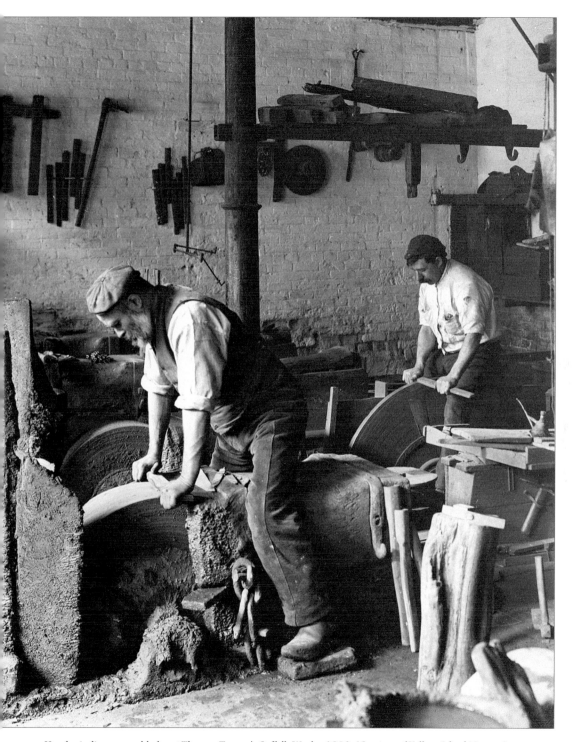

Hand grinding carver blades at Thomas Turner's Suffolk Works, 1902. (*Courtesy of Kelham Island Museum*)

Mr Buxton's scissor department at Thomas Turner & Co.'s Suffolk Works, *c.* 1902. (*Courtesy of Kelham Island Museum*)

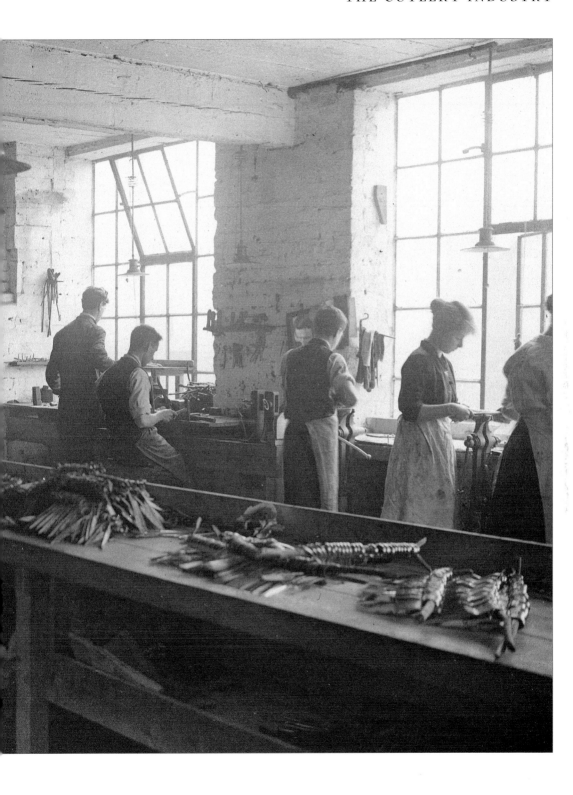

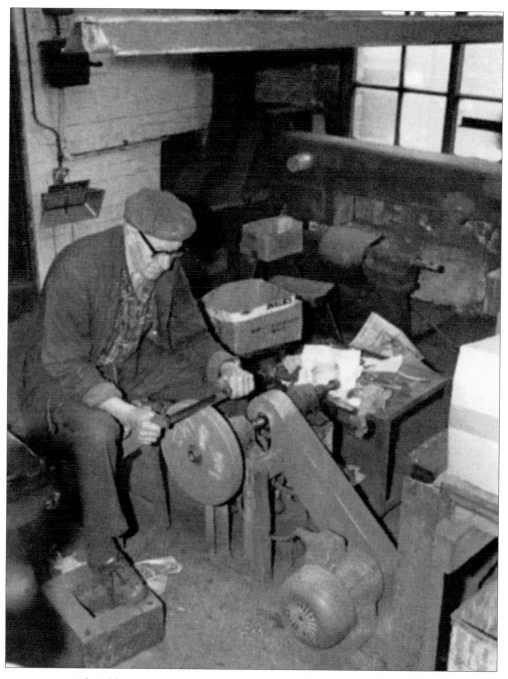

Jack Carl drystone grinding at Joseph Elliot & Sons, cutlers, Sylvester Street, 1981.
(*Courtesy of Sheffield Central Library*)

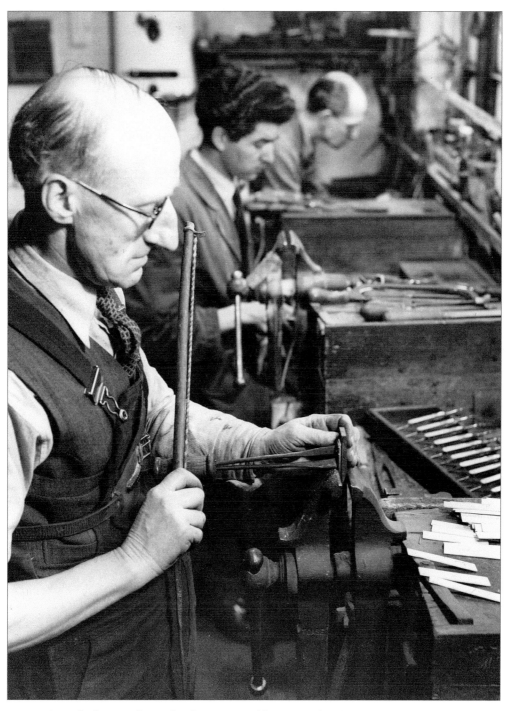

Using a 'parser' to bore stainless steel cutlery at George Ibberson & Co.'s Cutlery Works, Rockingham Street, in March 1953. Ibberson's used Firth's Staybrite steel. (*Courtesy of Kelham Island Museum*)

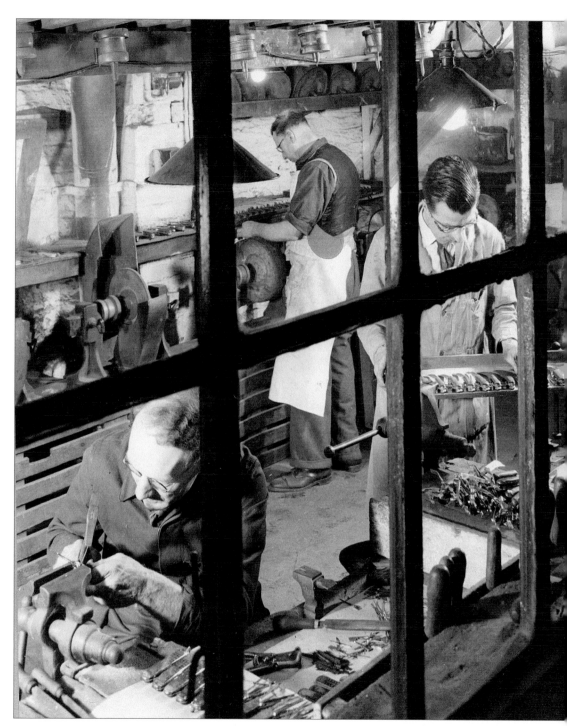

The cutlery shop at George Ibberson & Co.'s Cutlery Works, Rockingham Street, 27 March 1953. (*Courtesy of Kelham Island Museum*)

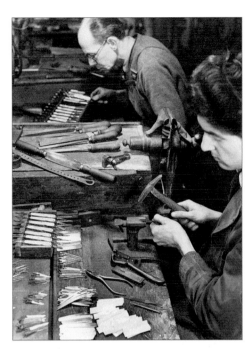

Making penknives at Ibberson's, 20 March 1953.
(*Courtesy of Kelham Island Museum*)

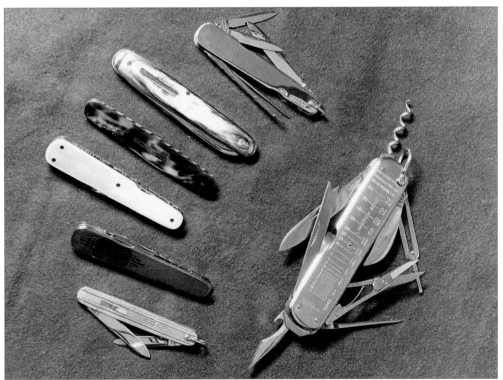

A selection of penknives made in March 1953 by George Ibberson & Co. (*Courtesy of Kelham Island Museum*)

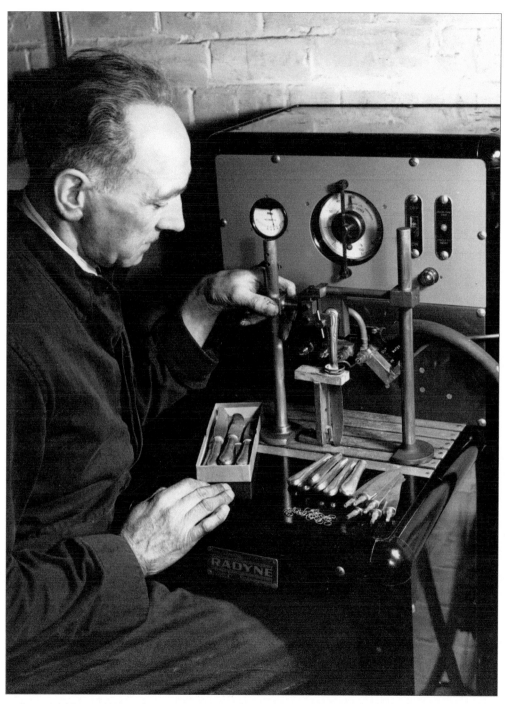

Induction welding Staybrite steel handles to stainless steel blades by high frequency induction coil heating, with electronic timing control, at Pearsons & Co., 5 January 1955. (*Courtesy of Kelham Island Museum*)

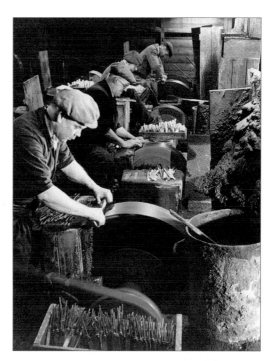

Hand grinding table knives at Mappin & Webb, 5 January 1955. (*Courtesy of Kelham Island Museum*)

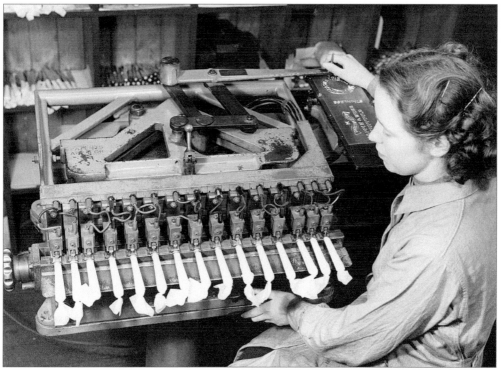

Electric etching of knife blades, Mappin & Webb, 6 January 1955. (*Courtesy of Kelham Island Museum*)

Visit Sheffield's Industrial Museums

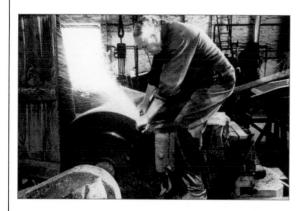

Abbeydale Industrial Hamlet

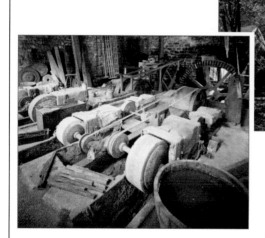

Shepherd Wheel

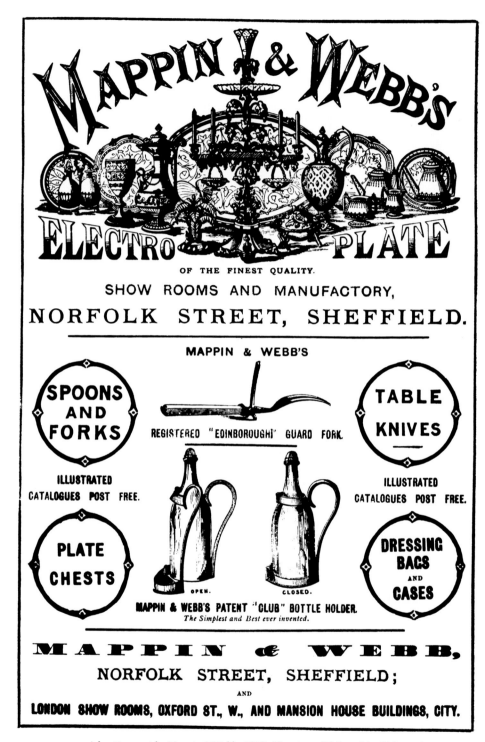

Advertisement for Mappin & Webb, 1879. (*Courtesy of Kelham Island Museum*)

Acknowledgements

Thanks are due to my personal assistant Mr John D. Murray, Mr Herbert and Mrs Doreen Howse, Mr Clifford and Mrs Margaret Willoughby, Mr David and Mrs Christine Walker of Walkers newsagents, Hoyland, Miss Nicola Lambert, Mr Harold Short, Mrs Doreen Nowak, John Bishop, Tracy P. Deller, Ricki S. Deller, Miss Joanna C. Murray Deller, Cyril Slinn, Mr Simon Fletcher, Miss Michelle Tilling, Mr Doug Hindmarch, Senior Local Studies Librarian, Sheffield City Library, and a particular thank you to Catherine Hamilton, Collections & Access Office, Kelham Island Museum.

An early Victorian advertisement for a range of goods
'Made in Sheffield'. (*Author's collection*)